Cool Restaurants
Toscana

teNeues

Imprint

Editors: Cecilia Fabiani, Martin Nicholas Kunz

Editorial coordination: Sabina Marreiros

Photos (location): Markus Bachmann (Bracali, Frateria di Padre Eligio Mondo, Il Bottaccio di Montignoso, La Mora, L'imbuto, Osteria da Tronca, Osteria la Solita Zuppa, Parodi Locanda del Castellano), Stefano Baroni (Lorenzo), Matteo Brogi (Il Canto), courtesy Arnolfo Ristorante Locanda (food), courtesy Castello Banfi Ristorante, courtesy La Tenda Rossa, courtesy Locanda Caino, courtesy Parodi Locanda del Castellano (food), courtesy San Donato in Perano Ristorante, Foto Style (La Vecchia Cantina), Guido Mannucci (Romano), Paolo Picciotto (La Vecchia Cantina / food).
All other photos by Martin Nicholas Kunz

Introduction: Cecilia Fabiani

Layout: Martin Nicholas Kunz

Imaging & Prepress: Jeremy Ellington

Translations: SAW Communications, Dr. Sabine Werner, Wiesbaden, Ulrike Brandhorst (German), Dr. Suzanne Kirkbright (English), Brigitte Villaumié (French), Carmen de Miguel (Spanish), Elke Buscher (German / recipes), Nina Hausberg (German, English / recipes)

Special thanks to Massimiliano Vaiani, Fabio Picchi, Simone Maglione, Francesco Cacciatori & Sonia Visman for their support and Axel Müller-Schöll & Regina Alt for their expert advise

Produced by fusion publishing GmbH, Stuttgart . Los Angeles www.fusion-publishing.com

Published by teNeues Publishing Group

teNeues Book Division
Kaistraße 18
40221 Düsseldorf, Germany
Tel.: 0049-(0)211-994597-0
Fax: 0049-(0)211-994597-40
E-mail: books@teneues.de

Press department:
arehn@teneues.de
Phone: 0049-2152-916-202

www.teneues.com

teNeues Publishing Company
16 West 22nd Street
New York, NY 10010, USA
Tel.: 001-212-627-9090
Fax: 001-212-627-9511

teNeues Publishing UK Ltd.
P.O. Box 402
West Byfleet
KT14 7ZF, Great Britain
Tel.: 0044-1932-403509
Fax: 0044-1932-403514

teNeues France S.A.R.L.
4, rue de Valence
75005 Paris, France
Tel.: 0033-1-55766205
Fax: 0033-1-55766419

teNeues Iberica S.L.
Pso. Juan de la Encina 2–48,
Urb. Club de Campo
28700 S.S.R.R. Madrid, Spain
Tel./Fax: 0034-91-65 95 876

ISBN-10: 3-8327-9102-7
ISBN-13: 978-3-8327-9102-5

© 2006 teNeues Verlag GmbH + Co. KG, Kempen

Printed in Italy

Bibliographic information published by Die Deutsche Bibliothek.
Die Deutsche Bibliothek lists this publication in the Deutsche Nationalbibliografie;
detailed bibliographic data is available in the Internet at http://dnb.ddb.de.

Average price reflects the average cost for a dinner main course without beverages. Recipes serve four.

Contents

Page

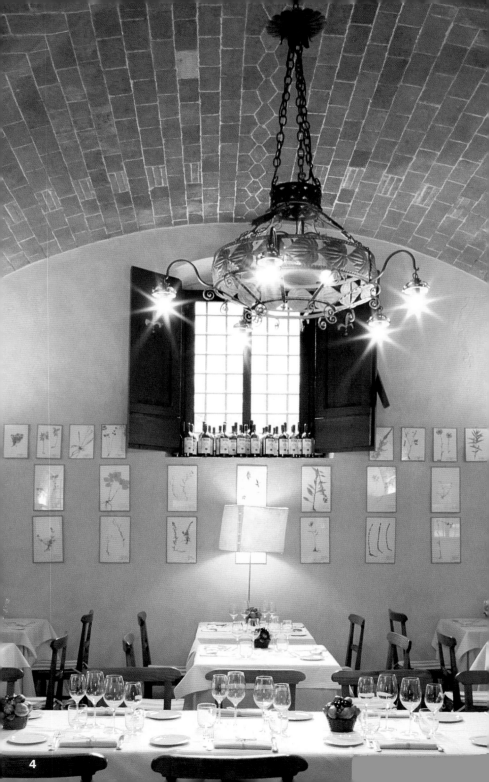

Introduzione

La Toscana è forse la regione più amata dagli stranieri che oltre a visitarla la hanno eletta in molti a seconda patria. Non è un caso che tra questi vi siano anche produttori di vino e grandi cuochi.

Nel Chianti, luogo di incontro internazionale, si parla da tempo di Chiantishire. Ad attirare ogni anno un turismo colto, sovente esclusivo, non sono unicamente le città d'arte con le loro opere e i piccoli centri, ricchi anch'essi di importanti capolavori, e neanche il paesaggio collinare con i famosi cipressi e le vigne, bensì un fortunato mix che passa anche attraverso la tavola, la cucina locale, le abitudini alimentari, di questa variegata regione, con piatti tipici, cibi gustosi, alimenti sani, vini famosi e schietti.

Per questo motivo Cool Restaurants Toscana è uno strumento che aiuta a capire la regione. La Toscana, come nessun'altra zona d'Italia e come pochi posti al mondo molto visitati, è stata capace di conservare le sue tradizioni culinarie che è riuscita a imporre. Nessuna concessione al turista, almeno in termini di cibo, a partire dal pane sciocco, ovvero senza sale, che si abbina bene ai sapori locali. Un atteggiamento che come il carattere burbero dei toscani, risulta rude al primo impatto e poi conquista.

Chi sceglie di visitare questa affascinante e ricca regione, che va dal mare alle colline, alle montagne, incontrerà sapori diversi, primi, pesce come carne, ma anche verdure e legumi, piatti della tradizione o rivisitati.

Cool Restaurants selezionati sono in molti casi situati in luoghi straordinari, per quanto riguarda la natura o l'architettura e presentano tutti una cucina di altissimo livello. Cool in Toscana è raramente un arredo di design avveniristico, più spesso un luogo di fascino, perché unico.

La nostra selezione è tesa ad accompagnarvi attraverso la regione, facendovi conoscere le molte sfaccettature della Toscana e dei suoi ristoranti: luoghi, aspetti e sapori.

<div align="right">Cecilia Fabiani</div>

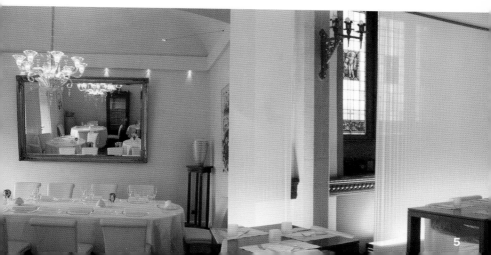

Introduction

Tuscany is one of Italy's most popular regions. For many, it is not just a place to visit, but rather their residence of choice. It is not surprising that some of these year-rounders happen to be famous wine-makers and chefs.

The Chianti region, occasionally dubbed "Chiantishire" has developed into an international meeting place. Every year, many, sometimes wealthy, cultural connoisseurs are attracted to Tuscany not only for the artworks of its cities, the sights of its picturesque villages and its hilly country side of cypress trees and vineyards, but for the attractive overall mixture that includes this region's culinary tradition. Its characteristic dishes, natural ingredients and famous fine wines, make Tuscany especially attractive.

Cool Restaurants Toscana provides a richly illustrated insight into this region, helping to better understand it. Like no other region in Italy and only a few of the world's tourist centers, it has succeeded in preserving and persevering in its culinary origins. As far as the cuisine is concerned, no concessions were made to tourism. One example is pane sciocco, an unsalted bread, which excellently suits the regional dishes and, just like the Tuscans, seems a little abrasive at first but then wins you over in the end.

Visitors to this rich and fascinating region, stretching from the sea over the hills to the mountains, can enjoy a great variety of tastes: "Primi" with homemade pasta, main dishes of fish or meat, vegetables and legumes prepared according to traditional or varied recipes.

The restaurants chosen for this book often feature outstanding locations or architecture and they all offer high-class cuisine. In Tuscany, "cool" hardly ever refers to a futuristic design interior, but rather to enchanting uniqueness.

Cool Restaurants Toscana is a guide to the whole region, featuring the multitude of aspects of the district and its master chefs, including tasty recipes to prepare at home.

Cecilia Fabian

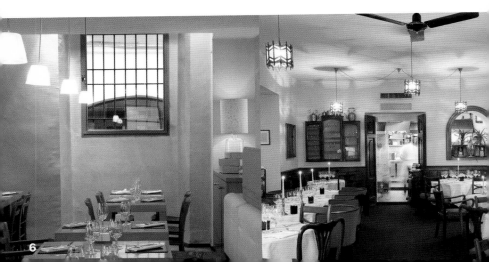

Einleitung

Die Toskana zählt zu den beliebtesten Regionen Italiens. Für viele ist sie nicht nur Ferienort, sondern Wahlheimat. So ist es kein Zufall, dass sich unter den Zugezogenen sowohl bekannte Weinbauern als auch Spitzenköche befinden.

Das Chianti-Gebiet, beizeiten auch „Chiantishire" genannt, hat sich zum internationalen Treffpunkt entwickelt. Es sind nicht nur die Kunstwerke in den Städten, die Sehenswürdigkeiten in den malerischen Dörfern oder die Hügellandschaft mit ihren Zypressen und Weinbergen, die jedes Jahr zahlreiche und mitunter wohlhabende Kulturliebhaber anziehen. Vielmehr ist es die attraktive Mischung, zu der auch die kulinarische Tradition dieser Region gehört. Mit ihren typischen Gerichten, natürlichen Zutaten und den berühmten Qualitätsweinen übt die Toskana eine besondere Anziehungskraft aus.

Cool Restaurants Toscana gibt einen bilderreichen Einblick in diesen Landstrich und hilft ihn zu verstehen. Wie keiner anderen Region Italiens – und wie nur wenigen Touristenzentren in der Welt – ist es der Toskana gelungen, ihre kulinarischen Wurzeln zu bewahren und durchzusetzen. Zumindest was die Küche anbelangt, wurden dem Tourismus keine Zugeständnisse gemacht. Ein Beispiel ist das pane sciocco, ein ungesalzenes Brot, das so gut zu den regionalen Gerichten passt und wie die Toskaner, zunächst etwas ruppig erscheint, einen dann aber doch für sich gewinnt.

Wer die reiche und faszinierende Region besucht, die sich vom Meer über die Hügel, bis hin zu den Bergen erstreckt, kann sich auf vielfältige Geschmackserlebnisse freuen: Primi mit hausgemachter Pasta, Hauptgerichte mit Fisch oder Fleisch, Gemüse und Hülsenfrüchte nach traditionellen oder variierten Rezepten.

Die für dieses Buch ausgewählten Lokale befinden sich an oft landschaftlich oder architektonisch außergewöhnlichen Orten und verfügen alle über eine Küche der Meisterklasse. Cool bedeutet für die Toskana in den seltensten Fällen eine Einrichtung mit futuristischem Design, sondern vielmehr Faszination durch Einzigartigkeit.

Cool Restaurants Toscana führt durch die Region und zeigt die zahlreichen Facetten des Landstrichs und seiner Meisterköche mit schmackhaften Rezepten für Zuhause.

Cecilia Fabiani

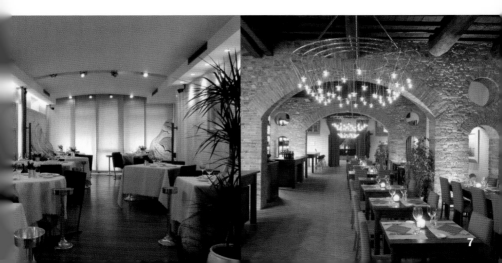

Introduction

La Toscane est une des régions d'Italie les plus appréciées. Pour beaucoup elle n'est pas seulement un lieu de villégiature, mais aussi une patrie d'adoption. Ce n'est pas par hasard que des viticulteurs connus ainsi que de grands chefs cuisiniers se comptent parmi les nouveaux résidents.

Le vignoble du Chianti, appelé depuis longtemps « Chiantishire », est devenu un point de rencontre international. Ce ne sont pas seulement les œuvres d'art dans les villes, les curiosités dans les pittoresques villages ou les paysages vallonnés avec leurs cyprès et vignobles qui attirent chaque année de nombreux amoureux de la culture, parfois très aisés. C'est plutôt ce mélange attirant, composé également des traditions culinaires de cette région. Avec ses plats typiques, ses produits naturels et ses célèbres vins de qualité, la Toscane exerce une force d'attraction particulière.

Cool Restaurants Toscana livre un panorama en images de cette province contribuant à la faire comprendre. Plus que toute autre région d'Italie et à l'instar de quelques rares centres touristiques au monde, la Toscane a réussi à préserver et imposer ses racines culinaires. Au moins en ce qui concerne la cuisine, aucun compromis n'a été consenti au tourisme. Le pane sciocco, pain sans sel qui va si bien avec les plats régionaux, en est un exemple : comme les Toscans, il semble bourru au premier abord, mais finit cependant par remporter l'adhésion.

Quiconque visite cette région riche et fascinante qui s'étend de la mer aux montagnes en passant par les collines, goûtera le plaisir de multiples expériences gustatives : des « primi » de pâtes maison, des plats de viandes ou de poissons, des légumes et des légumes secs, accommodés selon les traditions ou avec des variations.

Les établissements sélectionnés pour ce livre sont souvent situés dans des endroits exceptionnels soit pour le paysage soit pour l'architecture et proposent tous une cuisine des superlatifs. Pour la Toscane, Cool n'est que très rarement synonyme de design futuriste dans l'aménagement, mais plutôt de fascination par la singularité. Cool Restaurants Toscana vous fait traverser cette région en vous montrant les multiples aspects de cette province et de ses chefs cuisiniers avec de succulentes recettes à faire chez soi.

Cecilia Fabian

Introducción

La Toscana, una de las regiones preferidas de Italia, y para muchos no sólo lugar de vacaciones sino patria adoptiva, alberga, no por casualidad, a conocidos viticultores y cocineros de élite.

La región de Chianti, también llamada "Chiantishire", se ha convertido en un punto de encuentro internacional. La mágica fuerza de este lugar que año tras año atrae a numerosos amantes de la cultura, algunos acomodados, no se desprende exclusivamente de las obras artísticas de sus ciudades, los monumentos de sus pueblos pintorescos y los paisajes pintados de colinas, cipreses y viñedos; el atractivo lo aporta también la diversidad, de la que sin duda participa la tradición culinaria de esta región. La Toscana cautiva con sus platos típicos, ingredientes naturales y prestigiosos vinos.

Cool Restaurants Toscana lanza una mirada cargada de imágenes que ayuda a comprender la región. La Toscana ha sabido imponer y cultivar sus raíces culinarias como ninguna otra región en Italia, y como pocos lugares turísticos en el mundo; y al menos en lo que a la cocina se refiere, no ha hecho concesiones al turismo. Ejemplo claro es el pane sciocco, el pan sin sal que tan bien encaja con los platos regionales y que, como los toscanos, parece algo tosco al principio y cautiva al final.

Visitar esta fascinante región que abraza el mar y las montañas a través de un paisaje de colinas implica disfrutar de la diversidad de sabores: primi con pasta hecha en casa, platos principales de carne y pescado, o verdura y legumbres según recetas tradicionales y variadas.

Muchos de los locales seleccionados en esta obra están ubicados en entornos paisajísticos o arquitectónicos extraordinarios y ofrecen una cocina de élite. Para la Toscana, la expresión Cool no es casi nunca sinónimo de diseño futurista, sino más bien de fascinación y singularidad.

Cool Restaurants Toscana guía a través de esta región descubriendo sus más diversas facetas y a sus grandes cocineros, que aportan recetas exquisitas para deleitarse en casa.

Cecilia Fabiani

Albergaccio di Castellina

Design, Owners: Francesco Cacciatori, Sonia Visman
Chef: Sonia Visman

Via Fiorentina, 63 | 53011 Castellina in Chianti
Phone: +39 0577 741042
www.albergacciocast.com
Opening hours: Every day lunch 12:30 pm to 2 pm, dinner 7:30 pm to 9:30 pm
Menu price: € 43–50
Cuisine: Regional creative
Special features: Wine cellar and banqueting service for any kind of event

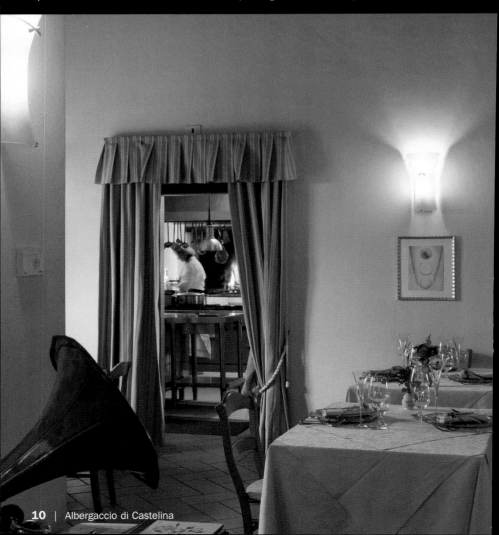

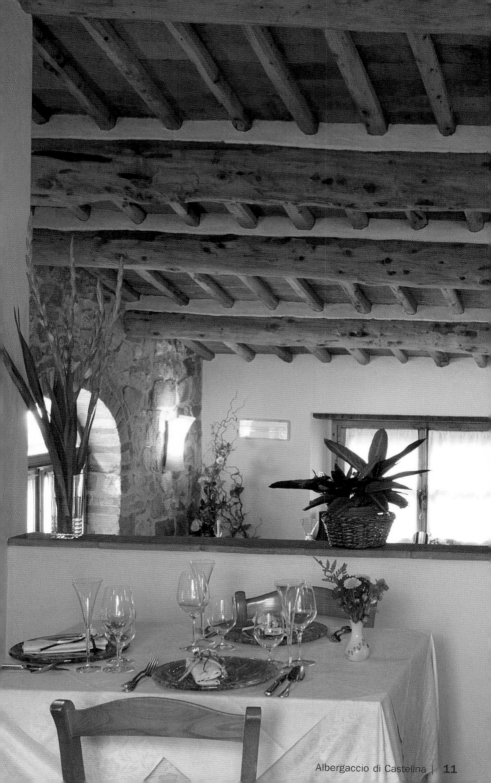

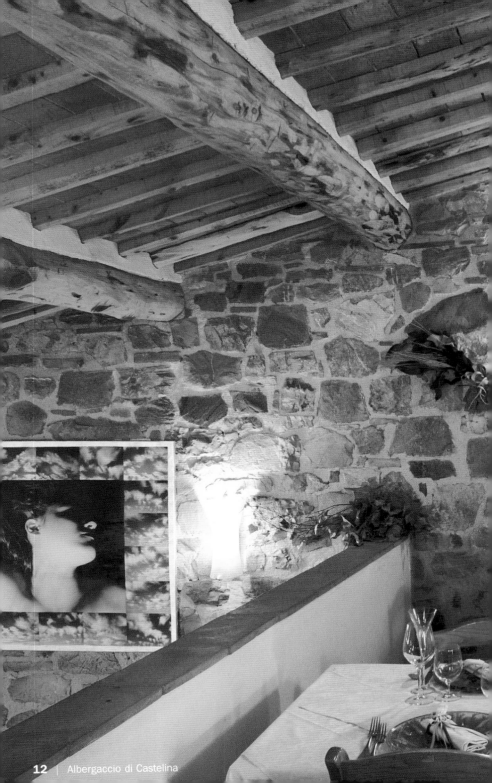

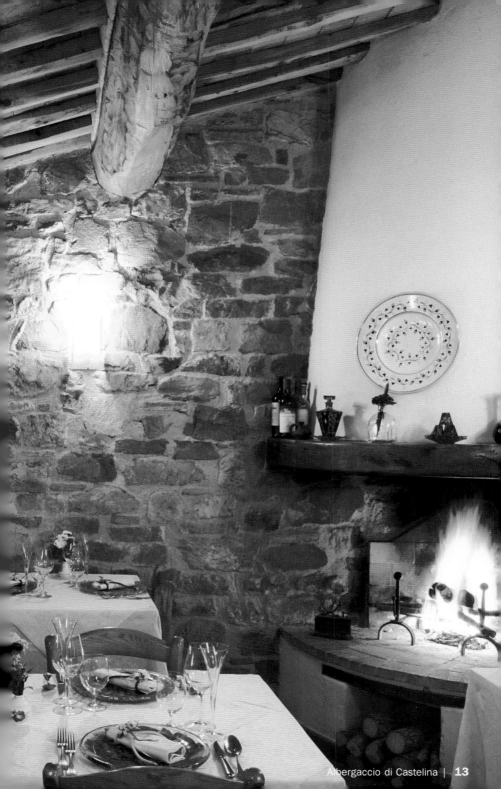

Angels

Design: James Cavagnari | Chef: Antonio Palumbo
Executive Manager: Bernacchioni Simone

Via del Proconsolo, 29–31/R | 50122 Florence
Phone: +39 055 2398762
www.ristoranteangels.it
Opening hours: Every day lunch noon to 3:00 pm, dinner 7:30 pm to midnight
Average price: € 50
Cuisine: Tuscan, Mediterranean
Special features: American Bar open from 7 pm every day

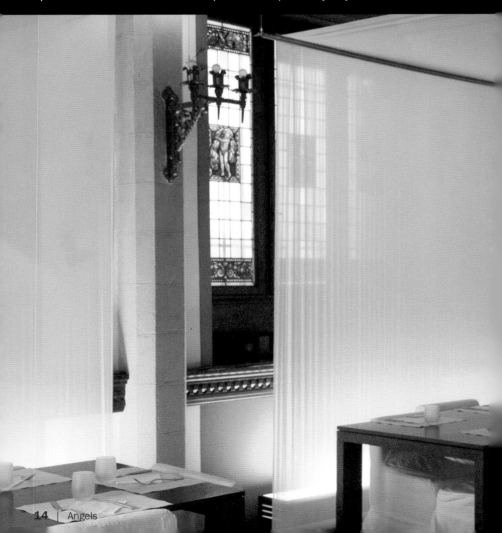

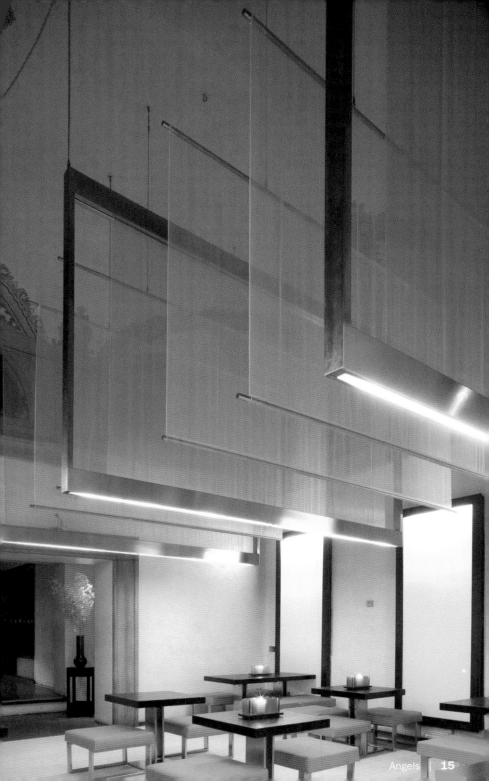

Pici senesi

500 g di pici o spaghetti

2 astici

3 cucchiai di olio di oliva
1 spicchio d'aglio tritato
6 pomodori grossi, spellati e spezzettati
120 ml di vino bianco
1 cucchiaio di dragoncello tritato
Sale, pepe

Per la guarnizione: erbe di stagione ed aceto balsamico

Lessare gli astici in abbondante acqua salata p 3 minuti. Cuocere al dente la pasta, scolarla tenerla da parte.
Tagliare gli astici a metà nel senso della lu ghezza, estrarre la carne della coda e tagliarla pezzetti. Rosolare l'aglio nell'olio di oliva, aggiu gere i pomodori e bagnare con il vino bian Insaporire con sale e pepe ed unire i pezzi astice e il dragoncello. Mescolare con la pasta farcire con il composto gli astici dimezzati.
Disporre su ogni piatto di pasta mezzo astice guarnire con le erbe e l'aceto balsamico.

1 lb 2 oz pici or spaghetti

2 lobsters

3 tbsp olive oil
1 clove of garlic, chopped
6 large tomatoes, skinned and diced
120 ml white wine
1 tbsp tarragon, chopped
Salt, pepper

Herbs of the season and balsamic vinegar for decoration

Boil lobsters in plenty of salted water for 3 m utes. Cook the pasta until al dente, drain a set aside.
Cut the lobsters in half lengthwise, remove tail meat and cut in pieces. Sauté the garlic olive oil, add the tomatoes and deglaze with wh wine. Season with salt and pepper and stir in lobster pieces and tarragon.
Mix with the pasta and fill into the halved l sters. Place one halved lobster on each plate a garnish with herbs and balsamic vinegar

500 g Pici oder Spaghetti

2 Hummer

3 EL Olivenöl
1 Knoblauchzehe, gehackt
6 große Tomaten, gehäutet und gewürfelt
120 ml Weißwein
1 EL Estragon, gehackt
Salz, Pfeffer

Kräuter der Saison und Balsamico-Essig zur
Dekoration

Hummer in reichlich Salzwasser 3 Minuten kochen. Pasta al dente kochen, abschütten und beiseite stellen.
Hummer längs halbieren, das Schwanzfleisch herauslösen und in Stücke schneiden. Den Knoblauch in Olivenöl anschwitzen, die Tomaten zufügen und mit Weißwein ablöschen. Mit Salz und Pfeffer würzen und die Hummerstücke und den Estragon unterrühren. Mit der Pasta mischen und in die halbierten Hummer füllen.
Jeweils einen halben Hummer mit Pasta auf jeden Teller legen und mit Kräutern und Balsamico-Essig garnieren.

00 g de pici ou de spaghettis

homards

c. à soupe d'huile d'olive
gousse d'ail hachée
grosses tomates pelées en dés
20 ml de vin blanc
c. à soupe d'estragon haché
el, poivre

erbes de saison et vinaigre balsamique pour la
coration

Faire cuire les homards 3 minutes dans un grand faitout d'eau salée. Faire cuire les pâtes al dente, égoutter et réserver.
Couper les homards en deux dans le sens de la longueur, extraire la chair des queues et la couper en morceaux. Faire fondre l'ail dans l'huile d'olive, ajouter les tomates et mouiller avec le vin blanc. Saler et poivrer; ajouter les morceaux de homard et l'estragon. Incorporer aux pâtes et verser dans les demi-coquilles.
Déposer un demi homard aux pâtes sur chaque assiette et garnir d'herbes de saison et de vinaigre balsamique.

00 g de pici o espagheti

langostas

cucharadas de aceite de oliva
diente de ajo picado
tomates grandes pelados y troceados
20 ml de vino blanco
cucharada de estragón picado
al y pimienta

nas hierbas de temporada y vinagre balsámico
ra adornar

Cocer las langostas en abundante agua salada durante 3 minutos. Cocer la pasta al dente, escurrirla y reservarla aparte.
Cortar las langostas longitudinalmente, separar la carne de la cola y trocearla. Sofreír el ajo en aceite de oliva, añadir los tomates y rociarlos con vino blanco. Salpimentarlos y añadirles los trozos de langosta y el estragón. Agregar la mezcla a la pasta y rellenar las mitades de langosta con ella.
Disponer en cada plato media langosta con pasta y decorar con las hierbas y el balsámico.

Arnolfo Ristorante Locanda

Design: Gaetano Trovato, Giovanni Trovato | Chef: Gaetano Trovato

Via XX Settembre, 50–52 | 53034 Colle di Val d'Elsa – Città Alta
Phone: +39 0577 920549
www.arnolfo.com
Opening hours: Thu–Mon lunch 1 pm to 4:30 pm, dinner 8 pm to midnight, closed
on Tue & Wed, holidays end of Jan until beginning of Mar, end of Jul to mid Aug
Average price: € 80–90
Cuisine: Tuscan, Mediterranean
Special features: Very light, creative and contemporary Tuscan cuisine

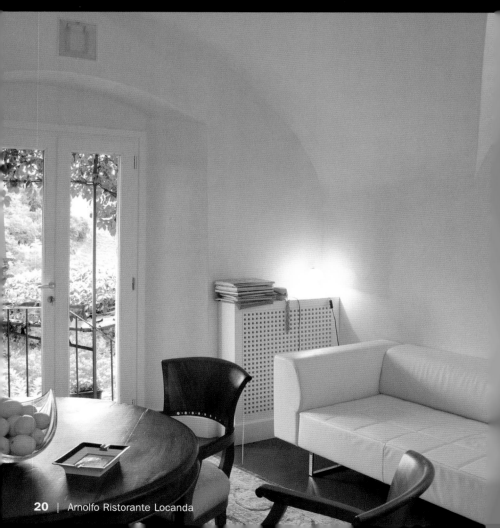

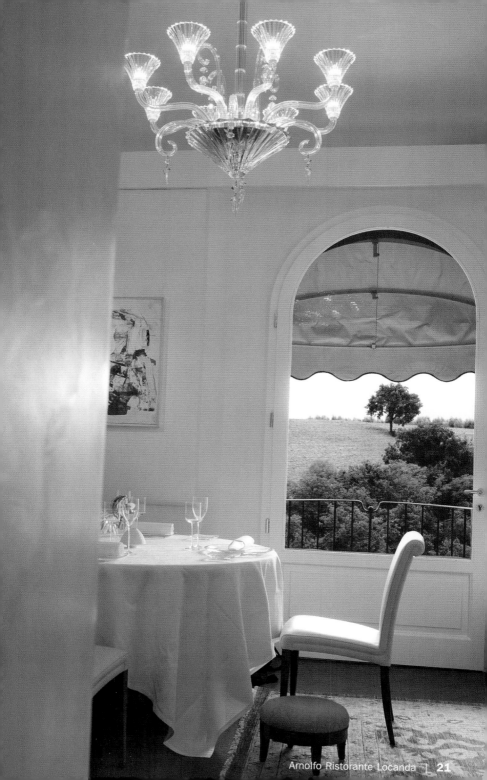

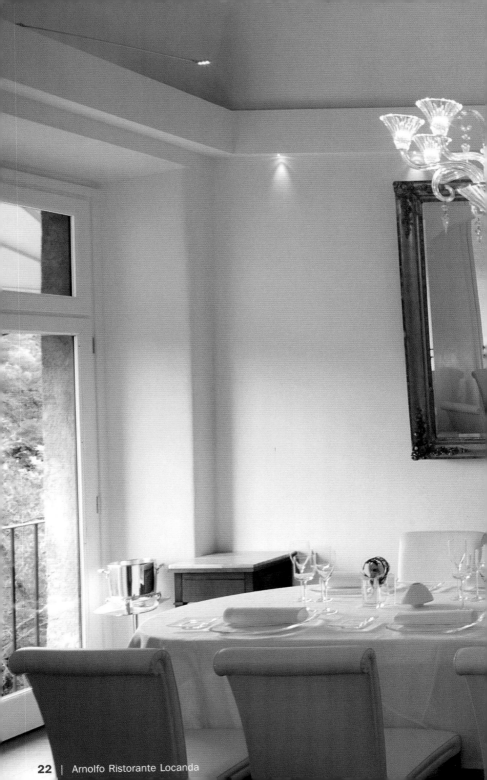

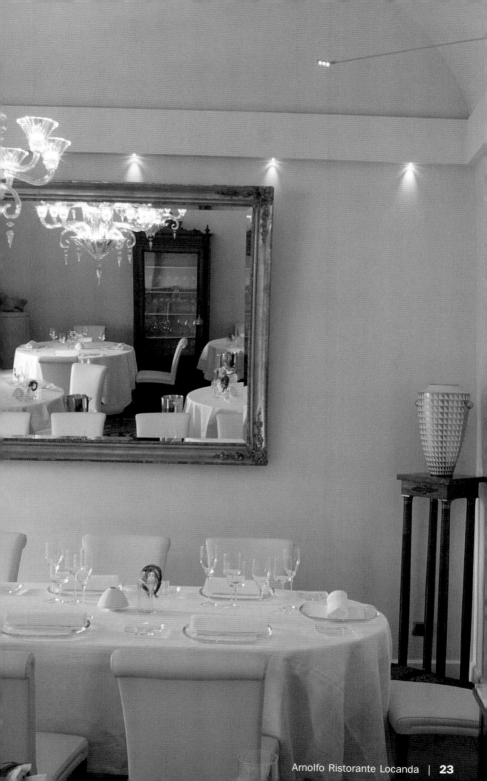

Variazione di vitello

Variation of Veal

Variation vom Kalb

Variation de veau

Variación de ternera

4 scalogni tagliati a dadini
2 chiodi di garofano
1 foglia di alloro
4 bacche di ginepro
200 ml di Vinsanto
200 ml di sugo di vitello

1 pezzo di sella di vitello, 14 x 8 x 8 cm
1 mazzetto di erbe miste
50 g di pangrattato
50 g di parmigiano grattugiato
4 fette di filetto di vitello di 50 g ciascuna
150 g di animelle di vitello
2 uova
Farina
Pangrattato per la panatura

1 peperone giallo e 1 rosso
4 mazzi di asparagi verdi

4 carotine novelle
2 finocchi piccoli
3 cucchiai di olio di oliva

Soffriggere gli scalogni con gli aromi, coprire ⊂
il Vinsanto e il sugo di vitello e lasciar restringe
Passare, assaggiare e regolare il condimento.
Sbollentare le animelle, pulirle e tagliarle
pezzetti. Incorporarvi la farina e l'uovo, sal
e pepare. Formare delle polpette e impana
Rosolare la sella di vitello per 1 minuto da t
i lati, condirla ed impanarla con un composto
erbe tritate, parmigiano e pangrattato.
Mondare le verdure, soffriggerle nell'olio di o
e condirle. Rosolare nell'olio di oliva le fette
vitello, la sella e le polpette di animelle e dispo
nei piatti. Servirle con le verdure pillottandole ⊂
il sugo e poco olio di oliva.

4 shallots
2 cloves
1 bay leave
4 juniper berries
200 ml Vinsanto
200 ml veal fond

1 piece of veal loin, 5 ½ x 3 x 3 inches
1 bunch mixed herbs
2 oz breadcrumbs
2 oz Parmesan, grated
4 slices veal sirloin
5 oz sweetbread
2 eggs
Flour
Breadcrumbs for breading

1 yellow and red bell pepper
4 green asparagus

4 baby carrots
2 baby fennel
3 tbsp olive oil

Sauté the shallots with the herbs, fill up v
Vinsanto and veal fond and reduce by cooki
Strain and season.
Blanch the sweetbread, clean and cut in sn
cubes. Mix with flour and one egg, and seas
with salt and pepper. Shape into balls and bre
Sear the veal loin for 1 minute on each si
Season loins with salt and pepper, and co
pletely cover them with a crust of chopped her
Parmesan and breadcrumbs.
Clean the vegetables and sauté in olive
Season with salt and pepper. Sear veal sirl
slices, breaded veal loin and sweetbread b
in olive oil and arrange on plates. Place the v
etables beside it and drizzle with some olive o

4 Schalotten, gewürfelt
2 Nelken
1 Lorbeerblatt
4 Wacholderbeeren
200 ml Vinsanto
200 ml Kalbsfond

1 Stück Kalbsrücken, 14 x 8 x 8 cm
1 Bund gemischte Kräuter
50 g Semmelbrösel
50 g Parmesan, gerieben
4 Scheiben Kalbsfilet, à 50 g
150 g Kalbsbries
2 Eier
Mehl
Semmelbrösel zum Panieren

1 gelbe und rote Paprika
4 Stangen grüner Spargel

4 Fingermöhren
2 Baby-Fenchel
3 EL Olivenöl

Die Schalotten mit den Gewürzen anschwitzen, mit Vinsanto und Kalbsfond aufgießen und reduzieren lassen. Passieren und abschmecken.
Das Kalbsbries blanchieren, putzen und klein schneiden. Mit Mehl und einem Ei mischen und mit Salz und Pfeffer würzen. Zu Kugeln formen und panieren. Den Kalbsrücken von allen Seiten 1 Minute anbraten, würzen und mit einer Panade aus gehackten Kräutern, Parmesan und Semmelbröseln panieren.
Das Gemüse putzen und in Olivenöl anschwitzen. Würzen. Kalbsfiletscheiben, panierten Kalbsrücken und Kalbsbrieskugeln in Olivenöl anbraten und auf den Tellern anrichten. Das Gemüse anlegen und mit der Sauce und etwas Olivenöl beträufeln.

échalotes en dés
clous de girofle
feuille de laurier
baies de genièvre
00 ml de Vinsanto
00 ml de fond de veau

morceau de selle de veau de 14 x 8 x 8 cm
bouquet d'herbes mélangées
0 g de chapelure
0 g de parmesan râpé
tranches de filet de veau de 50 g chacun
50 g de ris de veau
œufs
arine
hapelure pour paner

poivron rouge et un jaune
tiges d'asperge verte

4 carottes « doigt de Paris »
2 fenouils nouveaux
3 c. à soupe d'huile d'olive

Faire fondre les échalotes avec les aromates, mouiller avec le Vinsanto et le fond de veau et laisser réduire. Chinoiser la sauce et assaisonner.
Blanchir le ris de veau, le nettoyer et le couper en petits morceaux. Mélanger avec de la farine et un œuf, saler et poivrer. Former des boulettes et les paner. Saisir 1 minute la selle de veau sur toutes les faces, assaisonner et paner avec une panade composée des herbes hachées, du parmesan et de la chapelure.
Nettoyer les légumes et les faire fondre dans l'huile d'olive. Assaisonner. Saisir les tranches de filet de veau, la selle de veau panée et les boulettes de ris de veau dans de l'huile d'olive et dresser sur les assiettes. Disposer les légumes et napper de sauce avec quelques gouttes d'huile d'olive.

chalotas troceadas
clavos
hoja de laurel
bayas de enebro
0 ml de Vinsanto
0 ml de fondo de ternera

trozo de silla de ternera, 14 x 8 x 8 cm
ramillete de finas hierbas variadas
g de pan rallado
g de parmesano rallado
filetes de solomillo de ternera de 50 g
0 g de mollejas de ternera
huevos
rina
n rallado para empanar

imiento rojo y amarillo
espárragos verdes
anahorias pequeñas

2 bulbos de hinojo enanos
3 cucharadas de aceite de oliva

Sofreír las chalotas con las especias, rociarlas con Vinsanto y fondo de ternera y reducirlas. Tamizar y sazonar la mezcla.
Escaldar las mollejas, limpiarlas y cortarlas en trozos pequeños. Mezclarlas con harina y un huevo y salpimentarlas. Moldearlas en forma de bola y empanarlas. Rehogar la silla de ternera por ambos lados durante 1 minuto, sazonarla y empanarla con una mezcla de pan rallado, finas hierbas picadas y parmesano.
Limpiar la verdura, sofreírla en aceite de oliva y sazonarla. Freír en aceite de oliva los filetes de solomillo, la espaldilla empanada y las bolas de molleja y colocarlos en los platos. Agregar la verdura y rociar los platos con la salsa y un poco de aceite de oliva.

Beccofino Ristorante

Design: André Benaim | Chef: Victor Elagovan

Piazza degli Scarlatti, 1/R | 50125 Florence
Phone: +39 055 290076
www.beccofino.com
Opening hours: Tue–Sun 7 pm to 11 pm
Average price: € 50
Cuisine: Creative Tuscan
Special features: Summer terrace overlooking the Arno

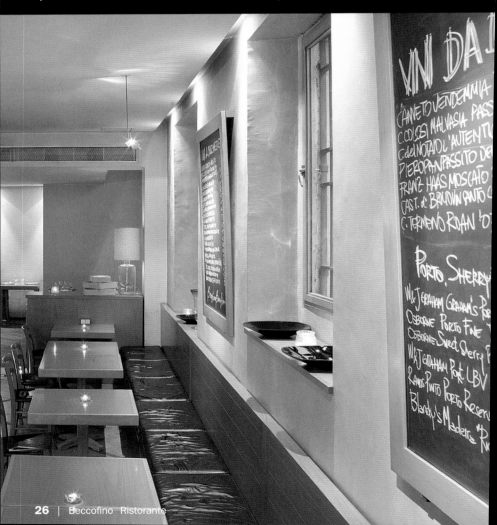

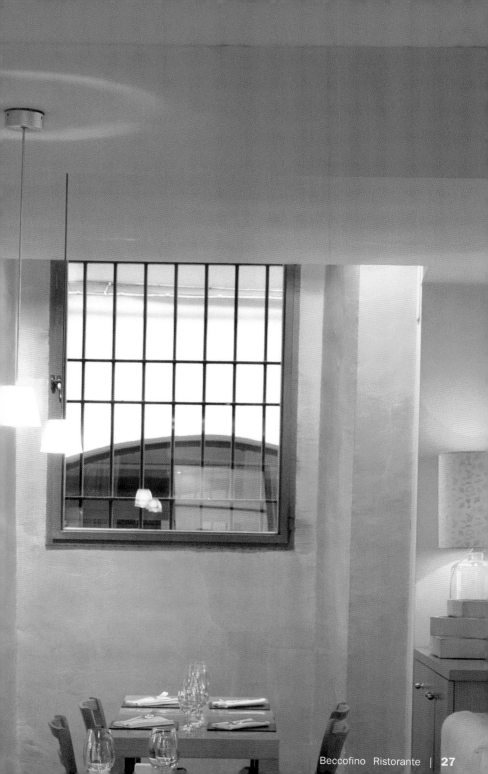

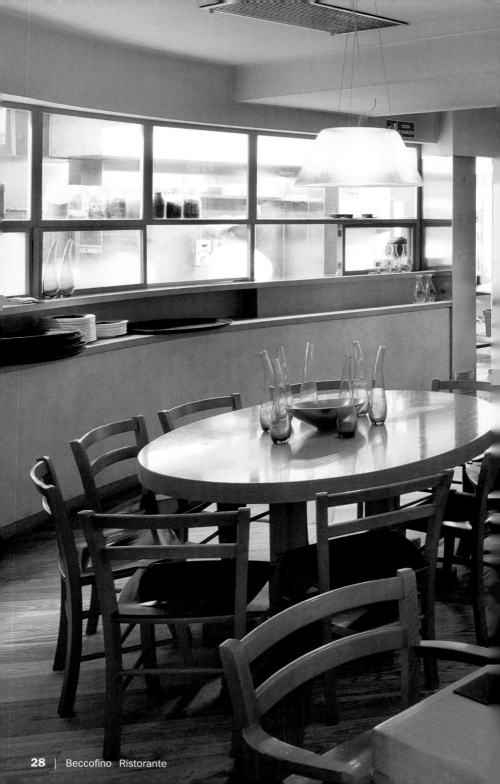

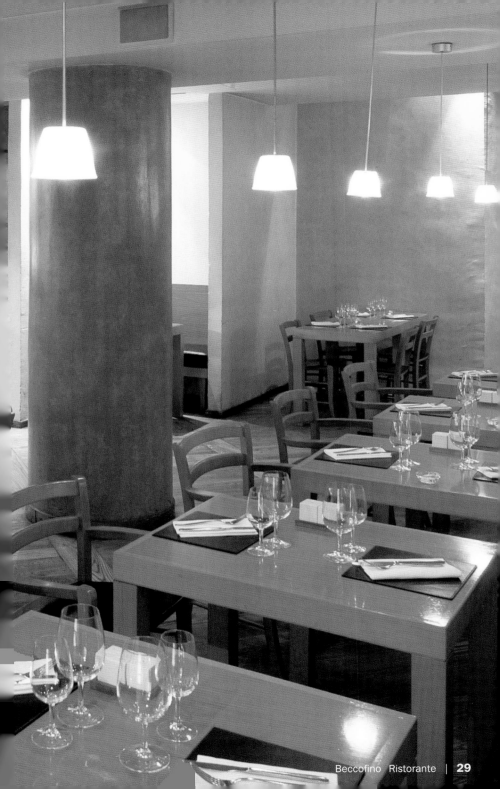

Bracali

Design, Chef: Francesco Bracali | Owners: Francesco &
Luca Bracali

Via di Perolla, 2 | Loc. Frazione Ghirlanda | 58024 Massa Marittima
Phone: +39 0566 902318
ristorantebracali@libero.it
Opening hours: Lunch Fri–Sun 1 pm to 2:30 pm, dinner Wed–Sun 8 pm to 10 pm,
closed on Mon & Tue
Menu price: € 100
Cuisine: Personal compositions of Francesco Bracali
Special features: Cigar room

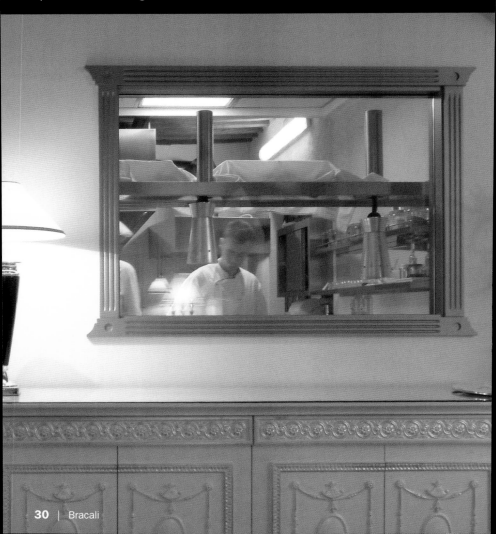

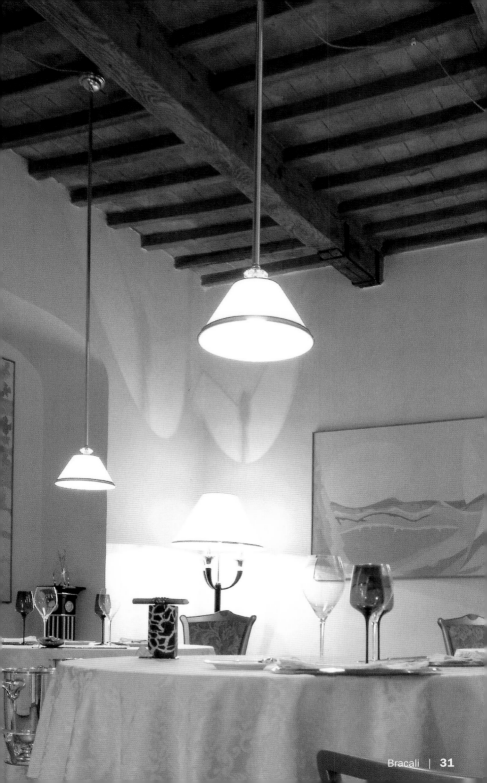

Castello Banfi Ristorante

Chef: Guido Haverkock | Owner: Mariani Family

Castello Di Poggio alle Mura | 53024 Montalcino
Phone: +39 0577 816054
www.castellobanfi.com
Opening hours: Tue–Sat 7:30 pm to 10 pm, closed on Sun & Mon
Menu price: € 110–140
Cuisine: Mediterranean
Special features: Wine cellar, hotel and glass museum

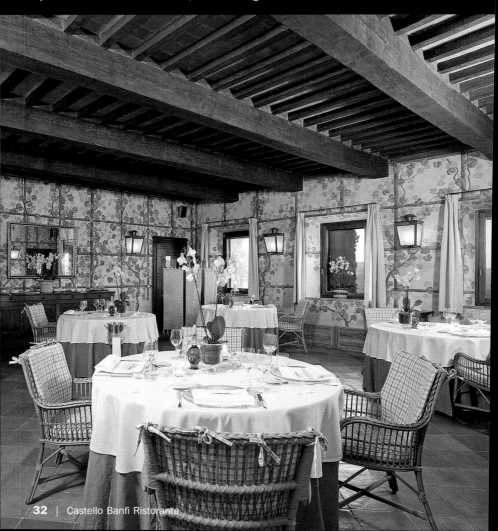

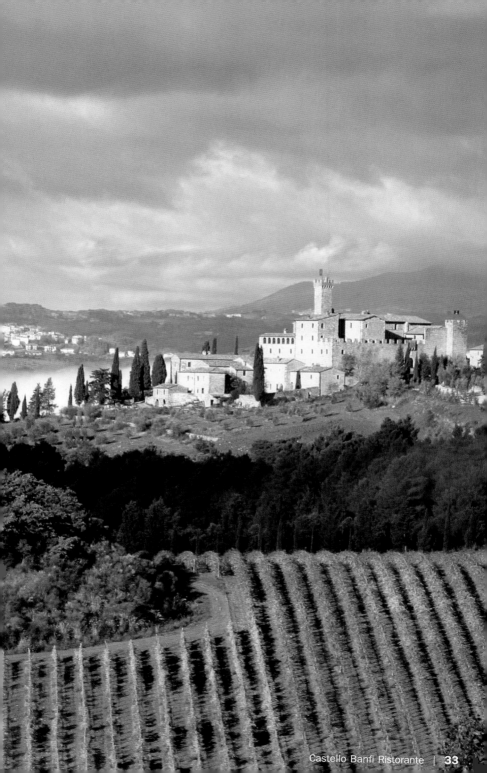

Cibrèo

Chef, Owner: Fabio Picchi

Via Andrea del Verrocchio, 8/R | 50122 Florence
Phone: +39 055 2341100
www.cibreo.it
Opening hours: Tue–Sat lunch 12:50 pm to 2:30 pm, dinner 7 pm to 11:15 pm
Menu price: € 64
Cuisine: Tuscan, traditional

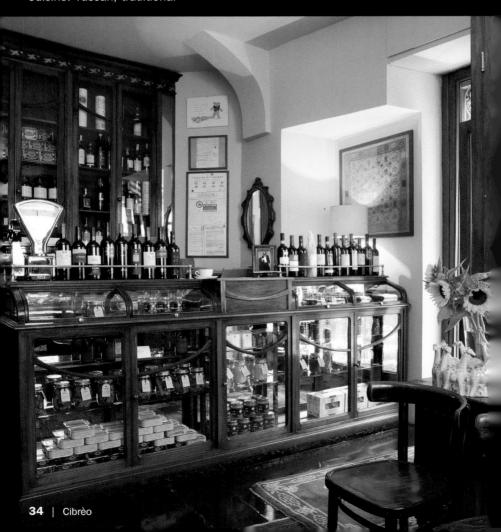

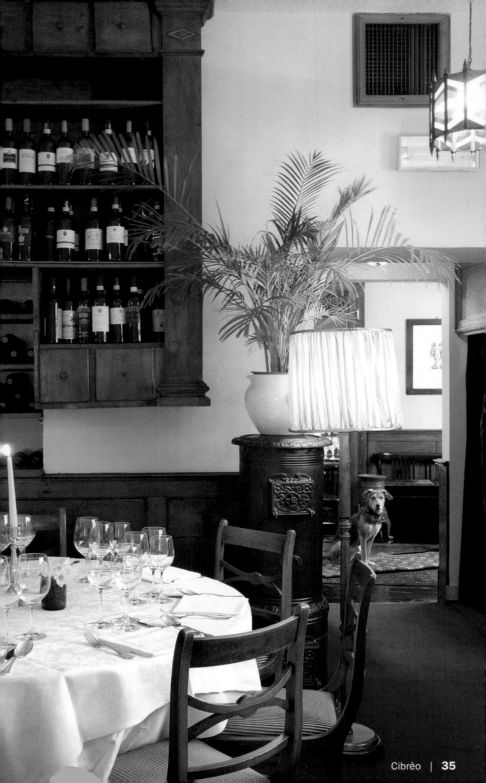

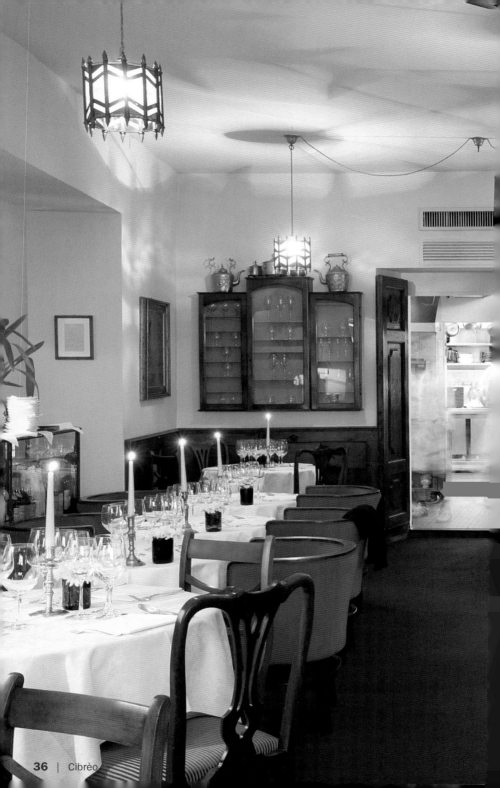

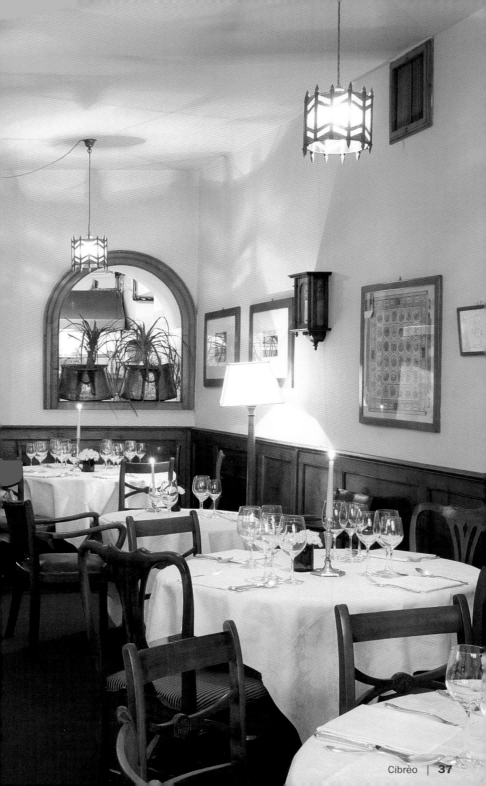

Enoteca Pinchiorri

Chef: Annie Féolde, Italo Bassi, Riccardo Monco
Owners: Giorgio Pinchiorri, Annie Féoldes

Via Ghibellina, 87 | 50122 Florence
Phone: +39 055 242777
www.enotecapinchiorri.com
Opening hours: Lunch Thu–Sat 12:30 pm to 2 pm, dinner Tue–Sat 7:30 pm to
10 pm, holidays Aug, Christmas, New Year's Day
Menu price: € 100
Cuisine: French, Tuscan
Special features: Unique wine cellar with about 150,000 bottles

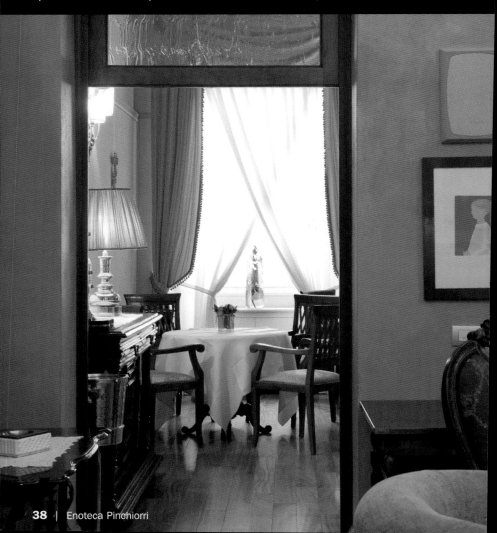

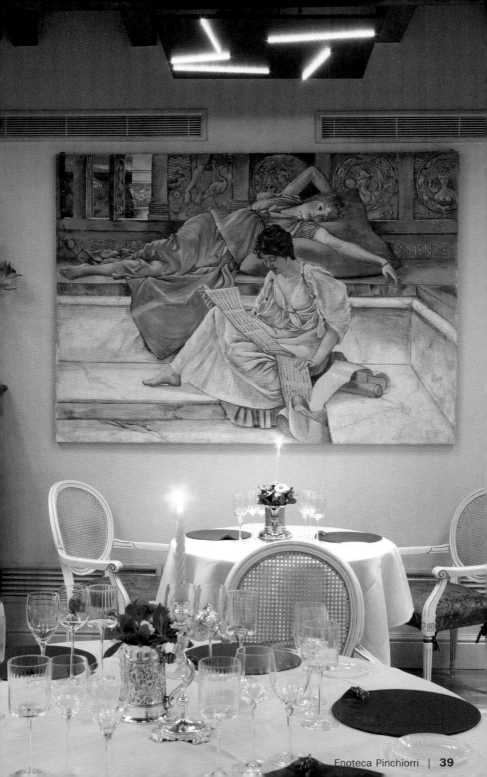

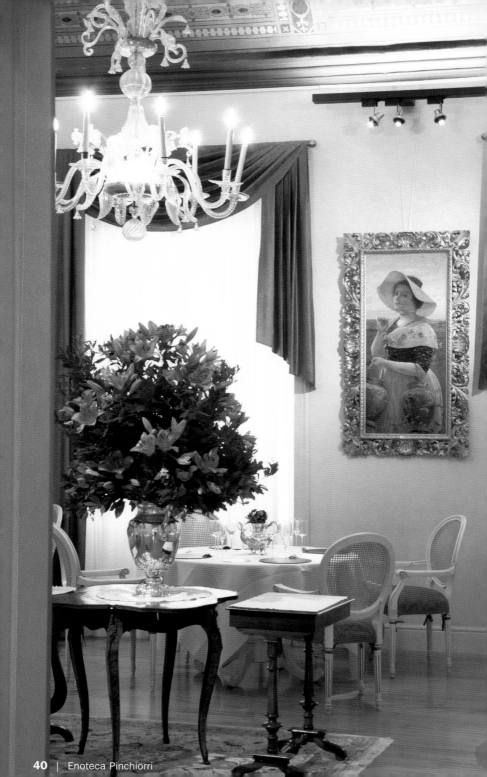

Filipepe

Design: Giuliana Fioretti, Francesca Corina
Chef: Francesco Coniglio | Owner: Peppino Corina

Via San Niccolo, 37–39/R | 50125 Florence
Phone: +39 055 2001397
www.filipepe.com
Opening hours: Every day 5 pm to midnight
Average price: € 30
Cuisine: Modern Mediterranean
Special features: Wine and cheese bar included

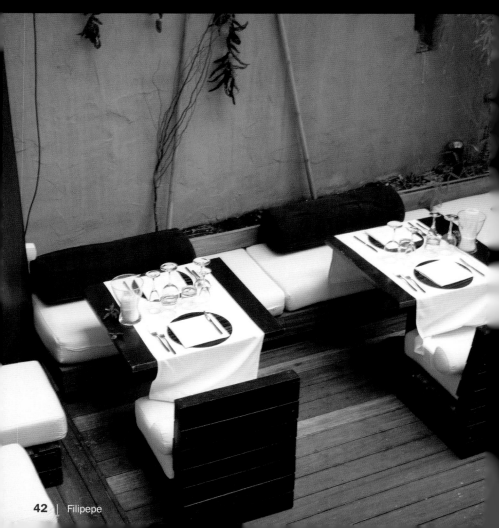

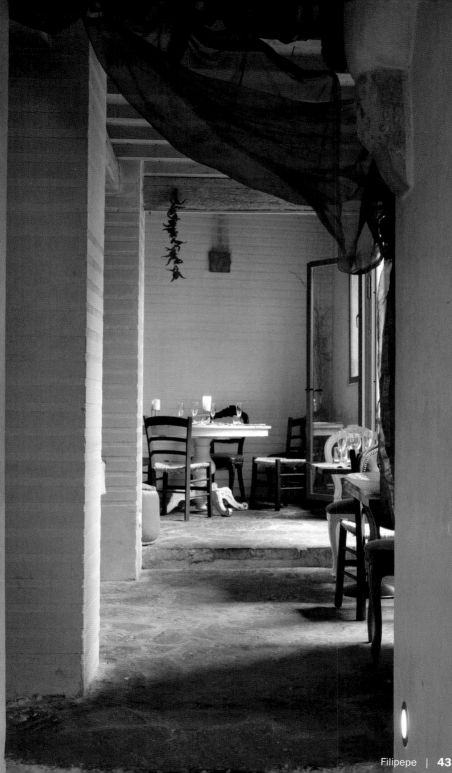

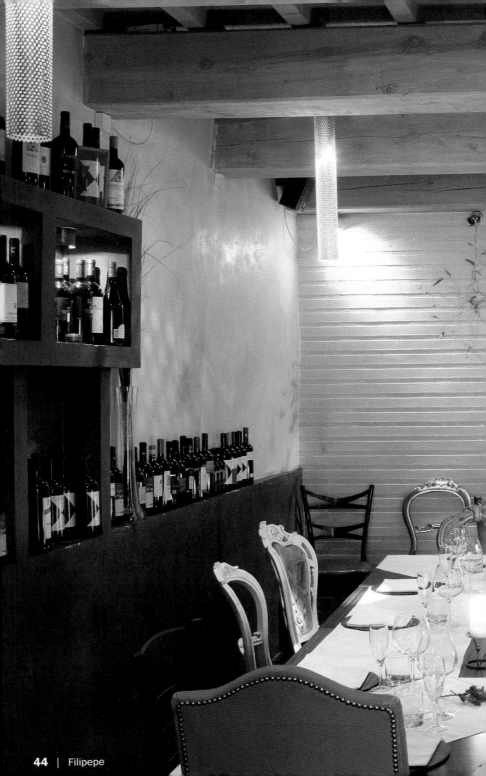

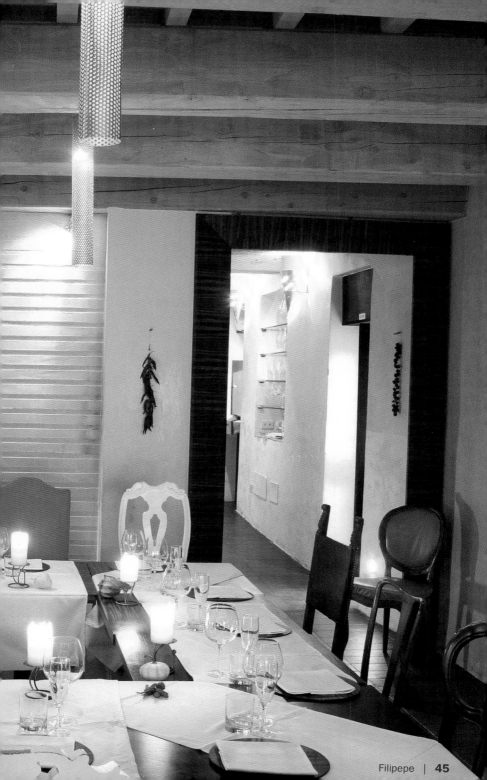

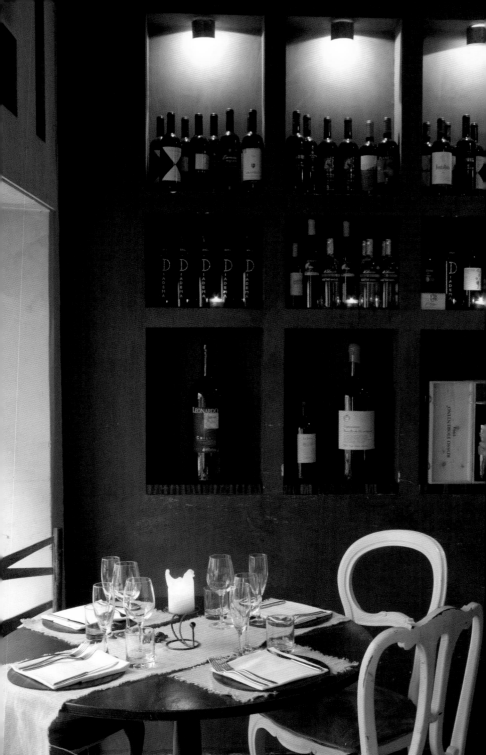

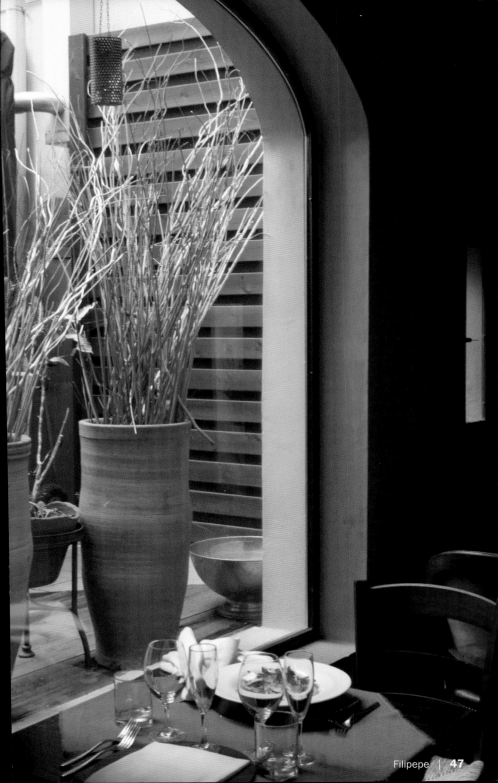

Millefoglie
di caciocavallo e zucchini

Millefeuille of Caciocavallo and Zucchini
Millefeuille von Caciocavallo und Zucchini
Millefeuille aux caciocavallo et courgettes
Milhojas de queso Caciocavallo y calabacín

4 zucchini rotondi (coltivazione speciale)
20 fette di formaggio caciocavallo
2 carote
1 mazzetto di basilico
3 cucchiai di aceto di vino bianco
2 cucchiai di olio di oliva
Sale, pepe

Tagliare a fette gli zucchini e disporli a str?
alternando uno zucchino affettato a 5 fette
formaggio. Condire ogni strato. Cuocere in for?
per 10 minuti a 180 °C.
Tagliare le carote a listarelle e marinarle per ?
minuti in aceto, olio di oliva, sale e pepe.
Disporre nei piatti le millefoglie con l'insalata
carote e le punte di basilico e servire con pa?
di tipo ciabatta.

4 round zucchini (special cultivation)
20 slices Caciocavallo cheese
2 carrots
1 bunch basil
3 tbsp white wine vinegar
2 tbsp olive oil
Salt, pepper

Cut the zucchini into slices and pile one ?
zucchini with 5 slices cheese on top of e?
other. Season every layer. Bake at 360 °F
10 minutes.
Cut the carrots in julienne and marinade with ?
egar, olive oil, salt and pepper for 10 minutes
Arrange the millefeuille with the carrot salad ?
basil tips on plates and serve with ciabatta.

4 runde Zucchini (spezielle Züchtung)
20 Scheiben Caciocavallo-Käse
2 Karotten
1 Bund Basilikum
3 EL Weißweinessig
2 EL Olivenöl
Salz, Pfeffer

Die Zucchini in Scheiben schneiden und jeweils eine geschnittene Zucchini und 5 Scheiben Käse abwechselnd zu einem Turm aufschichten. Jede Schicht würzen. Bei 180 °C für 10 Minuten backen.
Die Karotten in Julienne schneiden und mit Essig, Olivenöl, Salz und Pfeffer für 10 Minuten marinieren.
Die Millefeuille mit dem Karottensalat und Basilikumspitzen auf Tellern anrichten und mit Ciabatta servieren.

4 courgettes rondes (culture spéciale)
20 tranches de caciocavallo (fromage)
2 carottes
1 bouquet de basilic
3 c. à soupe de vinaigre de vin blanc
2 c. à soupe d'huile d'olive
sel, poivre

Trancher les courgettes en lamelles, utiliser 5 tranches de fromage par courgette et monter les millefeuilles en alternant les couches. Assaisonner chaque couche. Cuire au four à 180 °C pendant 10 minutes.
Couper les carottes en julienne et les laisser mariner 10 minutes dans le vinaigre et l'huile avec sel et poivre.
Dresser les millefeuilles avec la salade de carottes et du basilic ciselé sur les assiettes et servir avec de la ciabatta.

4 calabacines redondos (variedad especial)
20 lonchas de queso Caciocavallo
2 zanahorias
1 ramillete de albahaca
3 cucharadas de vinagre de vino blanco
2 cucharadas de aceite de oliva
sal y pimienta

Cortar los calabacines en rodajas y en cada calabacín intercalar 5 lonchas de queso, una por rodaja, formando una torre. Sazonar cada capa. Cocer los calabacines en el horno durante 10 minutos a 180 °C.
Trocear las zanahorias y marinarlas en vinagre, aceite de oliva, sal y pimienta durante 10 minutos.
Disponer en los platos las milhojas con la ensalada de zanahoria y las puntas de albahaca y servir con pan Ciabatta.

Frateria di Padre Eligio Mondo

Design: Padre Eligio | Chef: Walter Tripodi
Owner: Convento Mondo X

Via San Francesco, 2 | 53040 Cetona
Phone: +39 0578 238261
www.lafrateria.it
Opening hours: Every day lunch 1 pm to 2:30 pm, dinner 8 pm to 10 pm
Menu price: € 95
Cuisine: International, Tuscan

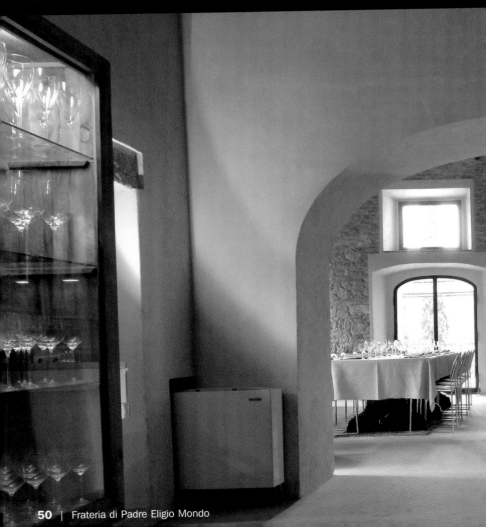

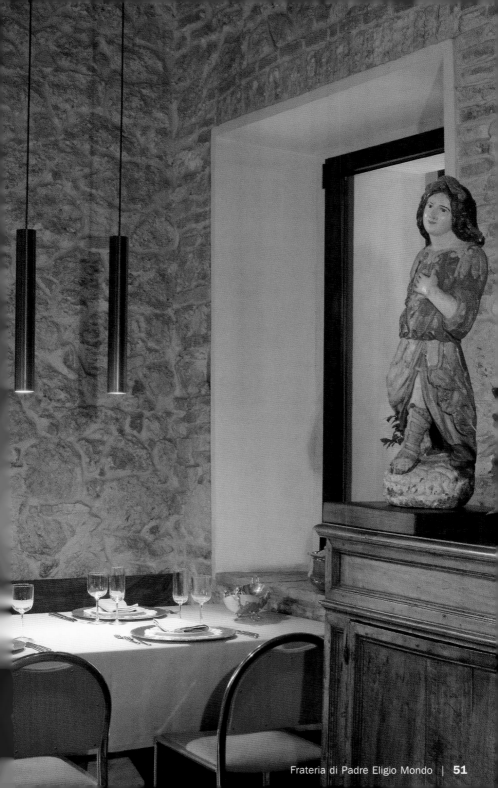

Granducato

Design & Owner: Massimiliano Vaiani | Chef: Elias Caschili

Via Tomerello, 1 | 50013 Campi Bisènzio
Phone: +39 055 8805111
www.boscolohotels.com
Opening hours: Every day breakfast 7 am to 11 am, lunch 12:30 pm to 3 pm,
dinner 7:30 pm to 11 pm
Average price: € 50
Cuisine: Typical Tuscan
Special feature: Spacious event facilities including winetasting, hotel

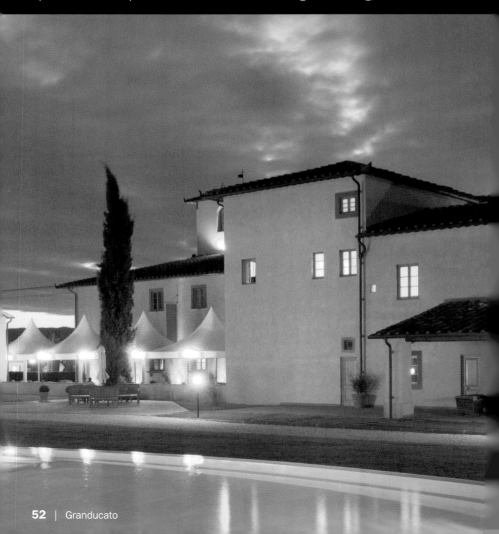

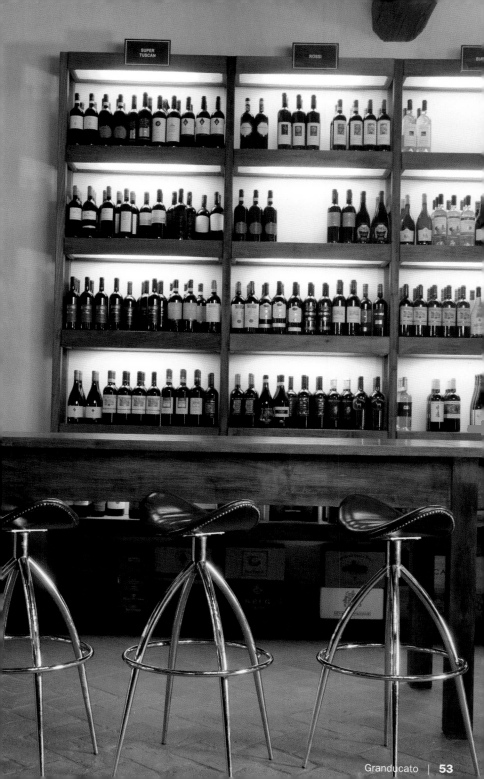

SUPER
TUSCAN

ROSSI

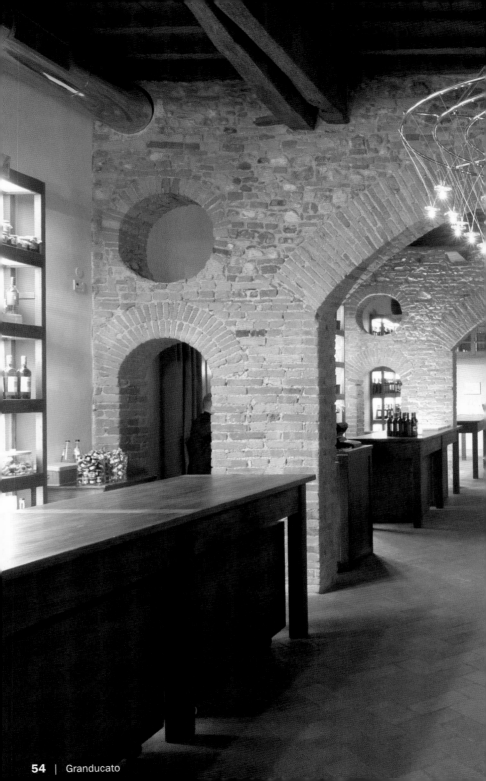

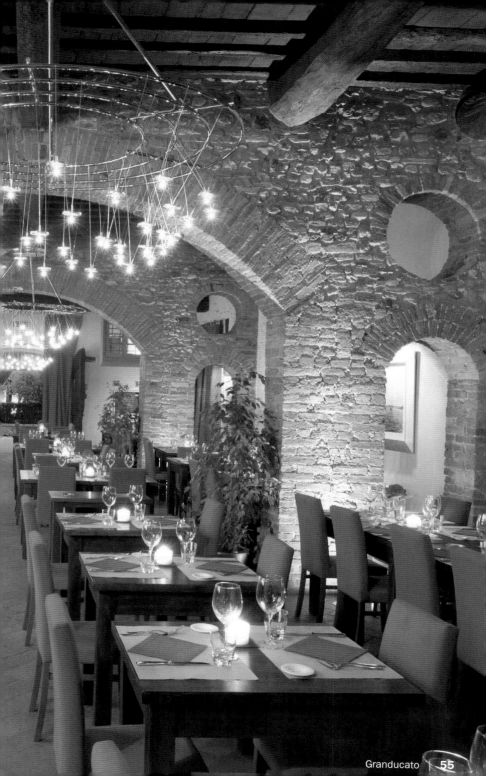

Il **Bottaccio** di Montignoso

Design & Owner: Elio D'Anna | Chef: Nino Mosca

Via Botttaccio, 1 | 54038 Montignoso
Phone: +39 0585 340031
www.bottaccio.it
Opening hours: Every day lunch noon to 3 pm, dinner 7:30 pm to 11 pm, flexible
opening hours with reservation
Menu price: € 80
Cuisine: Mediterranean, creative
Special features: Terrace, poolside dining, hotel

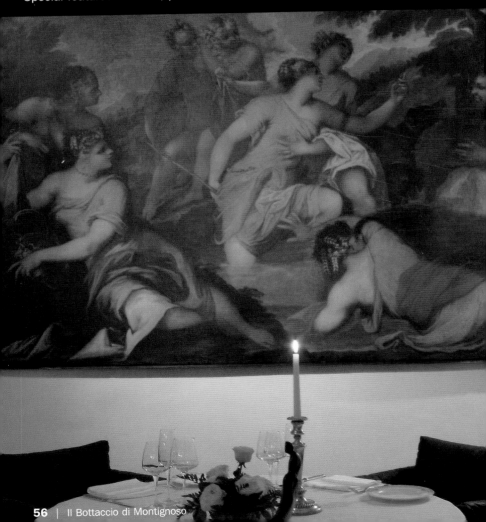

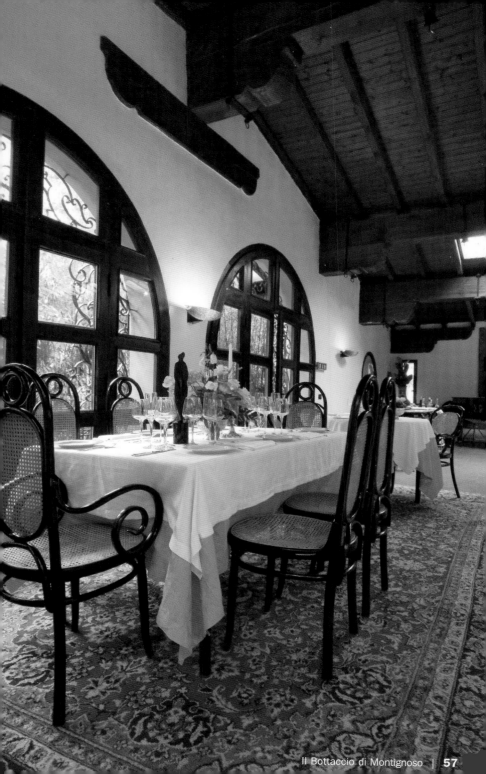

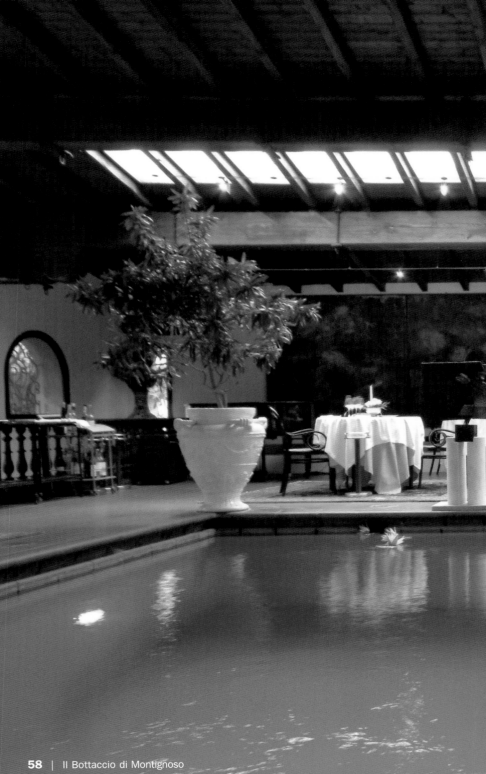

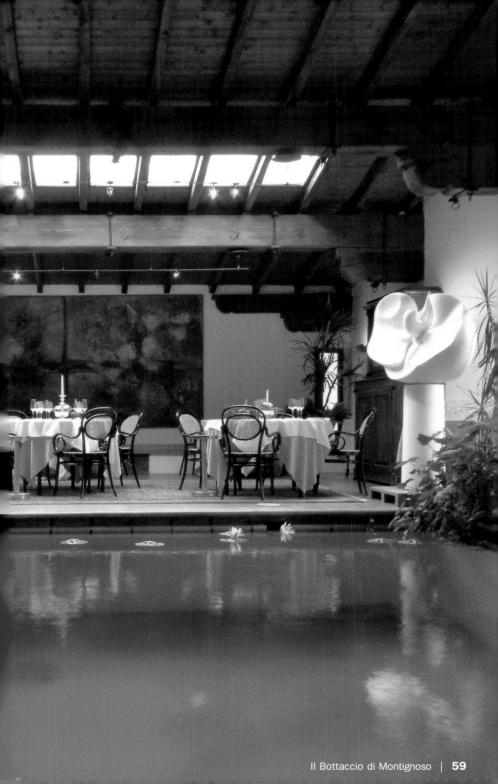

Il Canto

Design: Renzo Mongiardino | Chef: Paolo Lopriore
Owner: Anna Claudia Grossi

Strada di Certosa, 82/86 | 53100 Siena
Phone: +39 0577 288180
www.ilcanto.it
Opening hours: Every day lunch 1 pm to 2:30 pm, dinner 8 pm to 9:30 pm
Average price: € 70
Cuisine: Light Italian
Special features: Terrace overlooking Siena

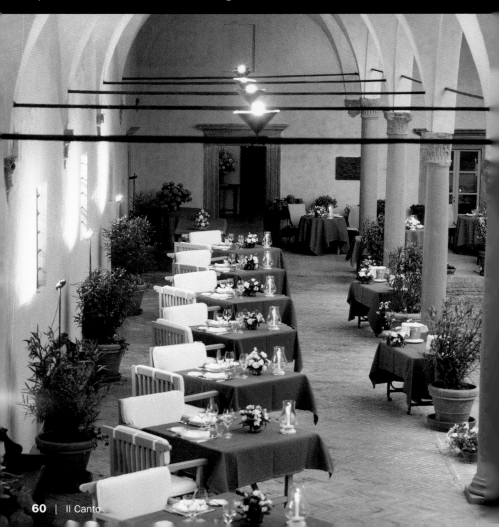

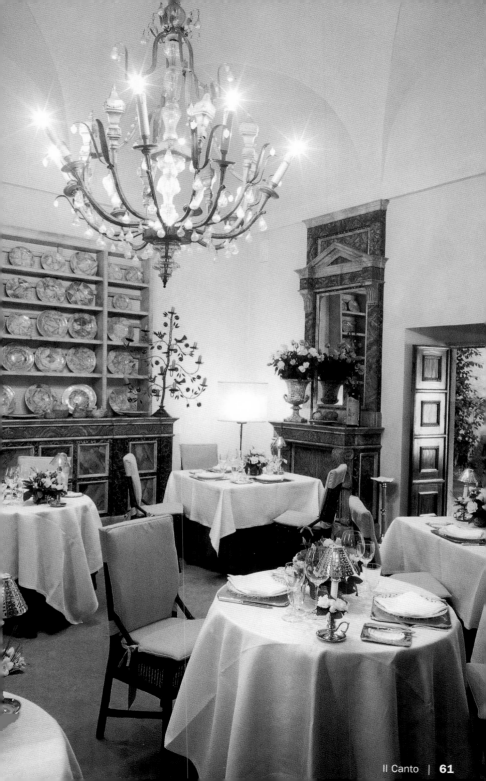

Risotto
alla marinara

Risotto Marinara Style
Risotto nach Marinara Art
Risotto à la marinara
Risotto a la marinera

4 ostriche
30 g di nero di seppia
30 g di coulis di crostacei (misto di gamberi
rossi e chili)
30 g di "acqua di mare" (misto di clorofilla di
prezzemolo e alghe)
6 cucchiai d'acqua

240 g di riso per risotti
2 cucchiai di burro
300 ml di vino bianco
600 ml d'acqua
Sale, pepe

Aprire le ostriche e ridurle in purea con la pro|
acqua. Passarle al setaccio e metterle in fresc(
Versare 2 cucchiai d'acqua in ognuno di
vaporizzatori ed aggiungere separatamente
nero di seppia, il coulis e l'"acqua di mare"
recipienti.
Soffriggere il riso nel burro, coprire poco a p(
con il vino bianco e l'acqua e farlo cuocere fin(
non sarà tenero. Incorporare la purea di ostric
salare e pepare.
Ripartire il risotto in quattro piatti e spruzzarvi i
macchia di ogni colore con i vaporizzatori.

4 oysters
1 oz sepia ink
1 oz shellfish coulis (mix of red shrimp and
chilis)
1 oz "seawater" (mix of parsley chlorophyll and
sea weed)
6 tbsp water

8 ½ oz risotto rice
2 tbsp butter
300 ml white wine
600 ml water
Salt, pepper

Open the oysters and blend with the inclu(
water. Pour through a strainer and set aside
chill.
Put 2 tbsp water in each of the three vaporiz(
and give the sepia ink, coulis and "seawa"
separately into each machine.
Heat the butter and gently sauté the ris(
rice, stirring to coat. Add in the white wine ¿
water, and allow it to absorb until soft. Stir in
blended oysters and continue simmering. Sea:
with salt and pepper.
Divide the risotto onto four plates and spra
circle of each color on the risotto.

4 Austern
30 g Sepiatinte
30 g Krustentier-Coulis (Mix aus roten Garnelen
und Chilis)
30 g „Meerwasser" (Mix aus Petersilienchloro-
phyl und Algen)
5 EL Wasser

240 g Risottoreis
2 EL Butter
300 ml Weißwein
500 ml Wasser
Salz, Pfeffer

Die Austern öffnen und mit dem eingeschlosse-
nen Wasser pürieren. Durch ein Sieb gießen und
kaltstellen.
Jeweils 2 EL Wasser in drei Verdampfer geben, und
die Sepiatinte, das Coulis und das „Meerwasser"
getrennt in die Geräte füllen.
Den Risottoreis in Butter anschwitzen, mit Weiß-
wein und Wasser nach und nach aufgießen und
weich kochen lassen. Das Austernpüree einrüh-
ren und mit Salz und Pfeffer würzen.
Das Risotto auf vier Tellern verteilen und mit den
Verdampfern von jeder Farbe einen Punkt auf das
Risotto sprühen.

huîtres
0 g de noir de sépia (encre noire de seiche)
0 g de coulis de crustacés (mélange de crevet-
es rouges et de piments)
0 g d'«eau de mer » (mélange de chlorophylle
e persil et d'algues)
c. à soupe d'eau

40 g de riz pour risotto
c. à soupe de beurre
00 ml de vin blanc
00 ml d'eau
el, poivre

Ouvrir les huîtres et réduire en purée avec l'eau
des coquilles. Passer au chinois et mettre au
frais.
Mettre respectivement 2 c. à soupe d'eau dans
trois évaporateurs, et remplir séparément les
appareils avec le noir de sépia, le coulis et « l'eau
de mer ».
Faire fondre le riz pour risotto dans le beurre,
mouiller peu à peu avec le vin blanc et l'eau et
cuire jusqu'à ce que le riz soit prêt. Incorporer la
purée d'huîtres, saler et poivrer.
Dresser le risotto sur quatre assiettes et vaporiser
avec les évaporateurs une touche de chaque
couleur sur le risotto.

ostras
g de tinta de sepia
g coulis de crustáceo (mezcla a base de
mbas rojas y chiles)
g de "agua marina" (mezcla a base de cloro-
a de perejil y algas)
cucharadas de agua

-0 g de arroz para risotto
cucharadas de mantequilla
0 ml de vino blanco
0 ml de agua
l y pimienta

Abrir las ostras y tamizarlas con su propia agua.
Pasarlas por un colador y reservarlas en frío.
Verter 2 cucharadas de agua en cada uno de los
tres vaporizadores y rellenarlos por separado con
la tinta de sepia, el coulis y el "agua marina".
Rehogar el arroz en mantequilla, agregarle pro-
gresivamente vino blanco y agua y cocerlo hasta
que esté al punto. Añadirle el puré de ostras y
salpimentarlo.
Repartir el arroz en cuatro platos y rociar con
cada vaporizador un punto de cada color sobre
el arroz.

La Mora

Chef: Luca Sicchi | Owner: Sauro Brunicardi

Via Sesto Di Moriano, 1748 | 55029 Ponte a Moriano–Lucca
Phone: +39 0583 406402
www.ristorantelamora.it
Opening hours: Thu–Tue lunch noon to 2 pm, dinner 7:30 pm to 10 pm, closed on
Wed, holidays beginning until mid of Jan, mid until end of Jun
Menu price: € 35–45
Cuisine: Typical Lucchesian

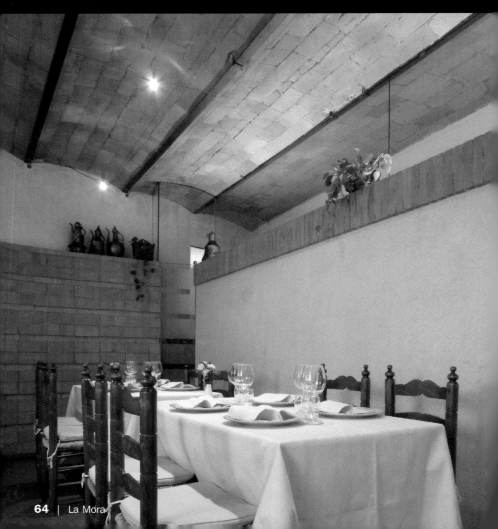

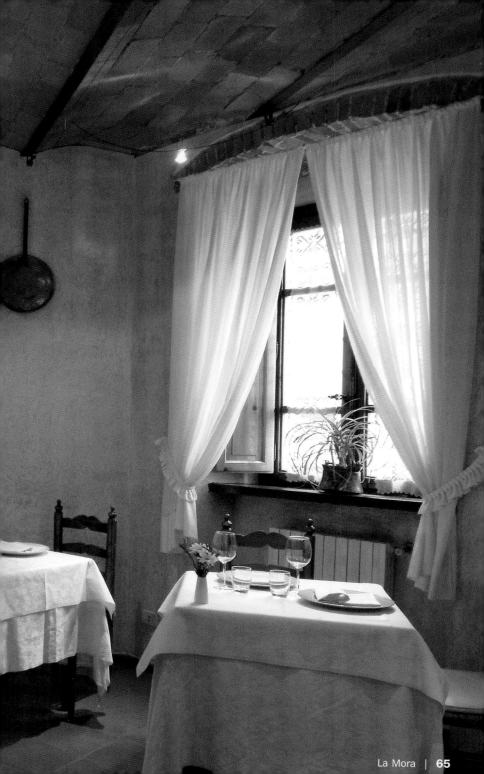

Cosciotti di coniglio ripieni
con purea di carote

Stuffed Rabbit Shanks with Mashed Carrots

Gefüllte Kaninchenschenkel mit Karottenpüree

Cuisses de lapin farcies et purée de carottes

Muslos de conejo rellenos con puré de zanahoria

4 cosciotti di coniglio
4 fegati di coniglio
1 cucchiaino di rosmarino tritato
Sale, pepe
Rete di maiale, 4 pezzi di 10 x 10 cm

2 cipolle tagliate a dadini
2 cucchiai di burro
4 carote sbucciate e tagliate a dadini
100 ml di succo di carota
Sale, pepe, zucchero

Per la guarnizione: foglie di basilico fritte

Disossare i cosciotti lasciandovi però all'inte
gli stinchi. Tritare grossolanamente i fegat
peparli. Farcire i cosciotti con l'impasto di feg
salare, pepare ed arrotolare ciascun cosciott
una rete di maiale. Cuocere in forno a 200 °C
circa 20 minuti.
Soffriggere la cipolla nel burro, aggiungere
carote tagliate a dadini ed allungare con il su
di carota. Far restringere e passare col pas
verdura. Assaggiare e regolare di sale, pep
zucchero.
Estrarre dal forno i cosciotti, eliminare gli even
li resti di rete di maiale e tagliarli a fette. Ser
con la purea di carote e le foglie di basilico.

4 rabbit shanks
4 rabbit livers
1 tsp rosemary, chopped
Salt, pepper
Pork net, 4 pieces, 4 x 4 inches

2 onions, diced
2 tbsp butter
4 carrots, peeled and diced into cubes
100 ml carrot juice
Salt, pepper, sugar

Fried basil leaves for decoration

Draw the shanks, but leave the shinbone in
shank. Roughly chop the livers and season
pepper. Stuff the liver mixture into the shanks, s
son with salt and pepper and wrap the shanks
the pork net. Bake at 390 °F for 20 minutes.
Sauté the diced onions in butter, add the car
and fill up with carrot juice. Reduce the li
by cooking and mash. Season with salt, pe
and sugar.
Take the rabbit shanks out of the oven, rem
the leftovers of the pork net, if necessary, and
the shanks into slices. Serve with mashed car
and basil leaves.

4 Kaninchenschenkel
4 Kaninchenlebern
1 TL Rosmarin, gehackt
Salz, Pfeffer
Schweinenetz, 4 Stück á 10 x 10 cm

2 Zwiebeln, gewürfelt
2 EL Butter
4 Karotten, geschält und gewürfelt
100 ml Karottensaft
Salz, Pfeffer, Zucker

frittierte Basilikumblätter zur Dekoration

Die Schenkel auslösen, den Schienbeinknochen aber im Schenkel belassen. Die Lebern grob hacken und mit Pfeffer würzen. Die Lebermasse in die Kaninchenschenkel füllen, salzen und pfeffern und jeden Schenkel in ein Schweinenetz wickeln. Bei 200 °C ca. 20 Minuten im Ofen garen.
Die Zwiebelwürfel in der Butter anschwitzen, die Karottenwürfel zugeben und mit Karottensaft auffüllen. Einkochen lassen und pürieren. Mit Salz, Pfeffer und Zucker abschmecken.
Die Kaninchenschenkel aus dem Ofen nehmen, evtl. Reste des Schweinenetzes entfernen und die Schenkel in Scheiben schneiden. Mit Karottenpüree und Basilikumblättern servieren.

cuisses de lapin
foies de lapin
c. à café de romarin haché
sel, poivre
crépine de porc, 4 morceaux de 10 x 10 cm

oignons en dés
c. à soupe de beurre
carottes épluchées en dés
00 ml de jus de carottes
sel, poivre, sucre

feuilles de basilic frites pour la décoration

Détailler les cuisses de lapin mais y laisser le tibia. Hacher grossièrement les foies et les poivrer. Farcir les cuisses des foies hachés, saler, poivrer et envelopper chaque cuisse dans une crépine de porc. Cuire au four à 200 °C env. 20 minutes.
Faire fondre les dés d'oignon dans le beurre, ajouter les dés de carottes et verser le jus de carottes. Laisser cuire puis réduire en purée. Réassaisonner de sel, poivre et sucre.
Retirer les cuisses de lapin du four, enlever les restes de crépine si nécessaire et couper les cuisses en tranches. Servir avec la purée de carottes et les feuilles de basilic.

muslos de conejo
hígados de conejo
cucharadita de romero picado
sal y pimienta
redaños de cerdo de 10 x 10 cm

cebollas picadas
cucharadas de mantequilla
zanahorias peladas y troceadas
0 ml de zumo de zanahoria
sal, pimienta y azúcar

hojas de albahaca fritas para adornar

Deshuesar los muslos pero dejando la tibia. Picar los hígados en trozos grandes y sazonarlos con pimienta. Rellenar los muslos con la masa de hígado, salpimentar y envolver cada muslo en un redaño. Asarlos en el horno durante 20 minutos aprox. a 200 °C.
Sofreír la cebolla picada en mantequilla, agregar la zanahoria y rociarla con el zumo de zanahoria. Rehogar y tamizar la mezcla. Sazonarla con sal, pimienta y azúcar.
Sacar los muslos del horno, quitar los posibles restos de redaño y cortarlos en rodajas. Servirlos con el puré de zanahoria y las hojas de albahaca.

La Tana degli Orsi

Design, Chef & Owner: Simone Maglione

Via Roma, 1 | 52015 Pratovècchio
Phone: +39 0575 583377
Opening hours: Thu–Tue dinner 7:30 pm to 10 pm, closed on Wed, holidays in Nov
Average price: € 30
Cuisine: Tuscan
Special features: Slow food

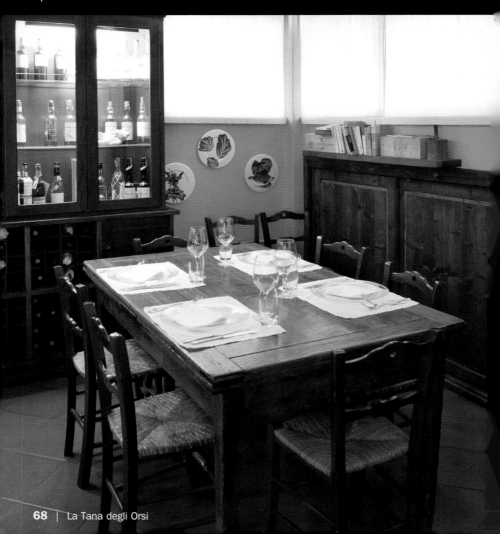

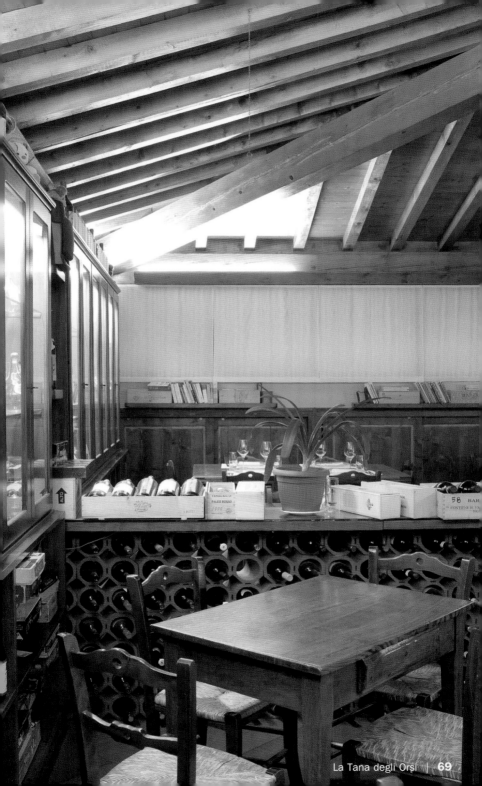

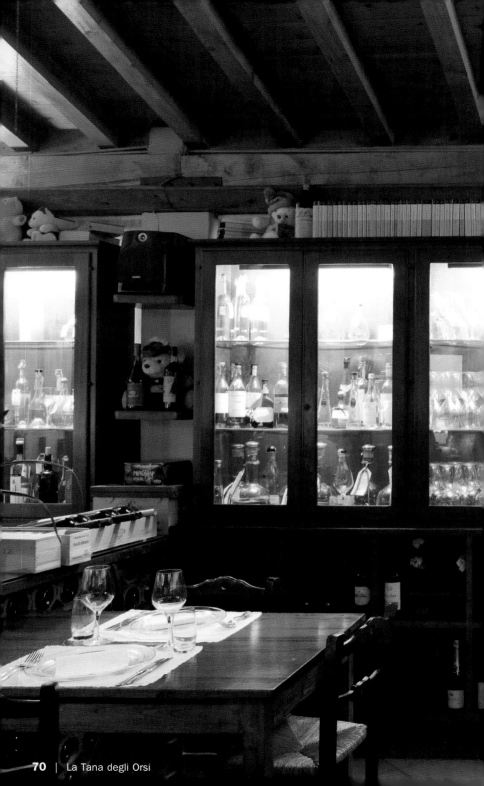

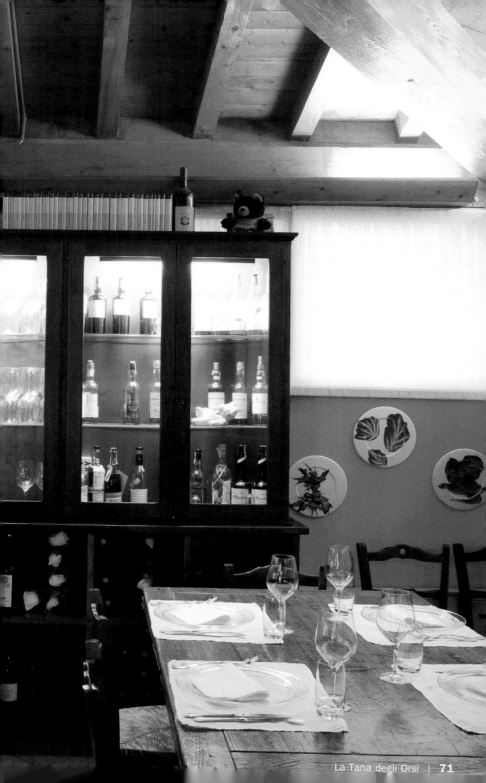

Gnocchi
con rigatino e pecorino

Gnocchi with Rigatino and Pecorino
Gnocchi mit Rigatino und Pecorino
Gnocchis aux rigatino et pecorino
Gnocchi con Rigatino y Pecorino

600 g di patate rosse
100 g di farina
2 tuorli d'uovo
1 uovo intero
2 cucchiai di pecorino grattugiato
Farina
Sale, pepe, noce moscata

2 cucchiai di burro
4 pezzi di formaggio rigatino di 120 g ciascuno
3 cucchiai di olio di oliva

Per la guarnizione: pecorino grattugiato, prezze-
molo tritato e pepe nero

Lessare le patate in acqua salata, scolarle
pelarle e passarle ancora calde nello schiaccia
patate. Amalgamarvi la farina, il tuorlo d'uovo
l'uovo, il pecorino e condire. Formare dei roto
del diametro di circa 1 cm e tagliarli in pezzetti
2 cm. Formare gli gnocchi e rigarli sui rebbi
una forchetta. Cuocerli in acqua salata bollent
per circa 7 minuti. Sgocciolarli e saltarli in padel
nel burro caldo.
Rosolare il rigatino nell'olio di oliva e condire
gnocchi con il formaggio nei piatti fondi. Guarni
con pecorino, prezzemolo e pepe nero.

1 lb 5 oz red potatoes
3 ½ oz flour
2 egg yolks
1 egg
2 tbsp Pecorino cheese
Flour
Salt, pepper, nutmeg

2 tbsp butter
4 pieces Rigatino cheese, 4 oz each
3 tbsp olive oil

Grated Pecorino, chopped parsley and black
pepper for decoration

Boil the potatoes in salted water. Drain, peel a
mash the potatoes while still warm. Mix with flou
egg yolks, egg and Pecorino cheese and seaso
Shape into rolls with a diameter of ½ inch a
cut into ¾ inch long pieces. Shape into gno
chi and press in the typical marks with a fo
Cook pieces in salted boiling water for appr
7 minutes. Drain, place in a pan, and coat w
hot butter.
Fry the Rigatino in olive oil and arrange with t
gnocchi in deep plates. Garnish with Pecorir
parsley and black pepper.

300 g rote Kartoffeln
100 g Mehl
2 Eigelbe
1 Ei
2 EL Pecorino, gerieben
Mehl
Salz, Pfeffer, Muskat

2 EL Butter
6 Stück Rigatino-Käse á 120 g
1 EL Olivenöl

geriebener Pecorino, gehackte Petersilie und
schwarzer Pfeffer zur Dekoration

Die Kartoffeln in Salzwasser kochen, abschütten,
schälen und noch warm durch die Kartoffelpresse
drücken. Mit Mehl, Eigelb, Ei und Pecorino
mischen und abschmecken. Daraus Rollen mit
einem Durchmesser von 1 cm formen und in
2 cm lange Stücke schneiden. Zu Gnocchi for-
men und mit einer Gabel die typischen Rillen ein-
drücken. In siedendem Salzwasser ca. 7 Minuten
gar ziehen lassen. Abtropfen lassen und in einer
Pfanne mit heißer Butter schwenken.
Den Rigatino in Olivenöl anbraten und die Gnocchi
in tiefen Tellern mit dem Käse anrichten. Mit
Pecorino, Petersilie und schwarzem Pfeffer gar-
nieren.

300 g de pommes de terre rouges
300 g de farine
2 jaunes d'œuf
1 œuf
2 c. à soupe de pecorino râpé
farine
sel, poivre, noix de muscade

2 c. à soupe de beurre
6 morceaux de fromage rigatino de 120 g chacun
1 c. à soupe d'huile d'olive

pecorino râpé, persil haché et poivre noir pour
décoration

Faire cuire les pommes de terre à l'eau salée,
égoutter, les éplucher et les passer encore chau-
des au presse-purée. Mélanger avec la farine, les
jaunes d'œuf, l'œuf et le pecorino et assaison-
ner. Former des rouleaux de 1 cm de diamètre
et couper des morceaux de 2 cm de long. En
former des gnocchis et faire avec une fourchette
les typiques rayures des gnocchis. Les faire cuire
env. 7 minutes dans de l'eau salée frémissante.
Egoutter et les faire dorer au beurre chaud dans
une poêle.
Faire revenir le rigatino dans de l'huile d'olive;
répartir les gnocchis dans des assiettes creuses
avec le fromage. Garnir de pecorino, de persil et
de poivre noir.

300 g de patatas rojas
300 g de harina
2 yemas de huevo
1 huevo
2 cucharadas de Pecorino rallado
harina
sal, pimienta y nuez moscada

2 cucharadas de mantequilla
6 trozos de queso Rigatino (de unos 120 g)
1 cucharadas de aceite de oliva

Pecorino rallado, perejil picado y pimienta negra
para adornar

Cocer las patatas en agua con sal, escurrirlas,
pelarlas y triturarlas aún calientes. Mezclarlas
con la harina, las yemas de huevo, el huevo y el
Pecorino y sazonarlas. Con la masa formar rollos
de 1 cm de diámetro y cortarlos en trozos de
2 cm de largo. Moldearlos en forma de Gnocchi
marcando las estrías típicas con un tenedor.
Cocer los Gnocchi en agua salada en ebullición
durante 7 minutos aprox. Escurrirlos y saltearlos
en una sartén con mantequilla caliente.
Sofreír el Rigatino en aceite de oliva y colocar los
Gnocchi con el queso en platos hondos. Decorar
con Pecorino, perejil y pimienta negra.

La Tenda Rossa

Design: Gianni Bondesan Studio, Atelier de architecture
Chef: Maria Salcuni | Owners: Santandrea & Salcuni Families

Piazza del Monumento, 9–14 | 50020 Cerbaia Val di Pesa
Phone: +39 055 826132
www.latendarossa.it
Opening hours: Every day lunch 12:30 pm to 2:30 pm, dinner 7:30 pm to 10 pm
Menu price: € 60–110
Cuisine: Italian, Tuscan

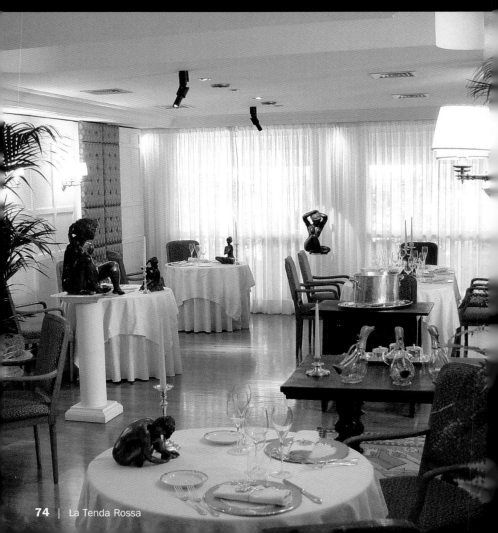

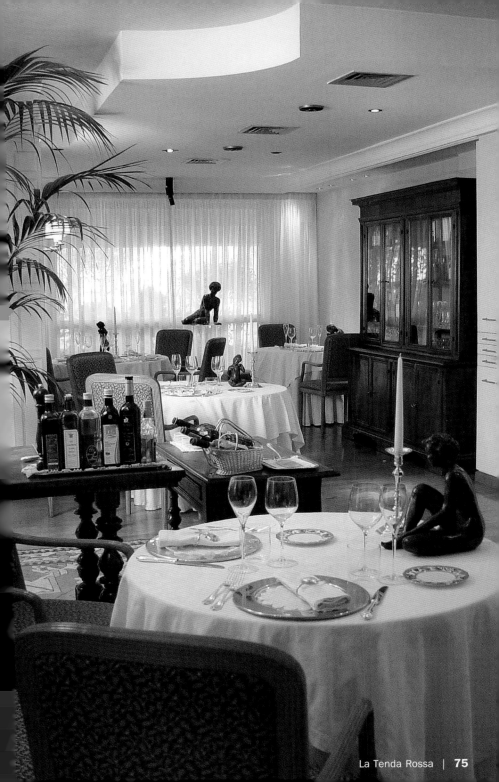

La Vecchia Cantina

Design, Owner: Alvaro Bartolomei | Chef: Maria Luisa Gori

Via Risorgimento, 4 | 51026 Maresca
Phone: +39 0573 64158
www.vecchiacantina.it
Opening hours: Every day lunch noon to 2:30 pm, dinner 7:15 to 10 pm,
closed on Tue, holidays in Nov
Average price: € 25–30
Cuisine: Italian, Tuscan

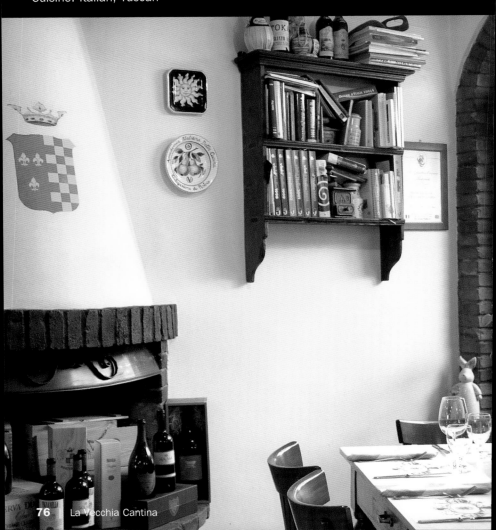

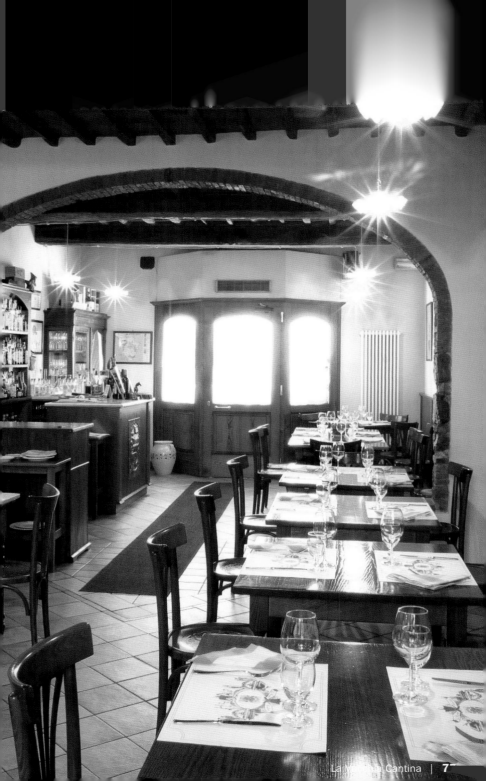

Costolette
di cinghiale con mosto e castagne

Wild Boar Chops with Grape Must and Chestnuts

Wildschweinkoteletts mit Most und Kastanien

Côtelettes de sanglier au moût et aux châtaignes

Chuletillas de jabalí al mosto con castañas

1 carrè di cinghiale con 8 costolette
Sale, pepe
5 foglie di salvia
2 foglie di alloro
1 ramoscello di rosmarino
3 cucchiai di olio di oliva

300 g di castagne sbucciate e stufate
3 cucchiai di burro
Sale, pepe

120 ml di mosto d'uva
180 ml di vino bianco

Strofinare il carrè di cinghiale con le erbe e l'oli d'oliva e condire. Metterlo in una teglia e cuocer in forno a 220 °C per circa 40 minuti.
Rosolare le castagne nel burro, condirle e met terle da parte.
Quando il carrè sarà pronto, toglierlo dalla tegl con gli odori e tenerlo al caldo. Portare a cottu il mosto d'uva e il vino bianco ed unirvi il sugo carne rimasto nella teglia. Assaggiare e regola il condimento.
Tagliare il carrè in otto pezzi e metterlo nel salsa insieme alle castagne. Servire con pata al rosmarino.

1 wild boar crown roast, with 8 chops
Salt, pepper
5 sage leaves
2 bay leaves
1 twig rosemary
3 tbsp olive oil

10 ½ oz chestnuts, peeled and steamed
3 tbsp butter
Salt, pepper

120 ml grape must
180 ml white wine

Salt and pepper the chops. Rub the wild bo crown roast with a marinate of rosemary, sag bay leaves, and olive oil. Place chops in a bakin dish so each chop lies flat. Roast chops at 430 for approx. 40 minutes in the oven.
Sauté the chestnuts in butter and season w salt and pepper. Set aside.
When the wild boar crown roast is tender, ta out of the baking dish and keep warm. In a sm saucepan, reduce the white wine with must. A the meat juices from the baking dish into t saucepan and season with salt and pepper.
Carve the roast into eight pieces and place cho on plate with the chestnuts and sauce. Serve w rosemary potatoes.

Wildschweincarré, mit 8 Kotelletts
alz, Pfeffer
Salbeiblätter
Lorbeerblätter
Zweig Rosmarin
EL Olivenöl

0 g Kastanien, geschält und gedünstet
EL Butter
lz, Pfeffer

0 ml Traubenmost
0 ml Weißwein

Das Wildschweincarré mit den Kräutern und dem Olivenöl einreiben und würzen. In eine Backform geben und bei 220 °C ca. 40 Minuten im Backofen schmoren.
Die Kastanien in Butter anbraten und würzen. Beiseite stellen.
Wenn das Wildschweincarré gar ist, mit den Kräutern aus der Form nehmen und warm stellen.
Den Traubenmost mit dem Weißwein aufkochen und die Fleischsäfte aus der Backform zugeben. Abschmecken.
Das Wildschweincarré in acht Teile schneiden und mit den Kastanien in die Sauce legen. Dazu passen Rosmarinkartoffeln.

arré de sanglier avec 8 côtelettes
, poivre
euilles de sauge
euilles de laurier
ranche de romarin
. à soupe d'huile d'olive

0 g de châtaignes épluchées et cuites
. à soupe de beurre
, poivre

0 ml de moût de raisin
0 ml de vin blanc

Frotter le carré de sanglier avec les aromates et l'huile d'olive et assaisonner. Le déposer dans un plat allant au four et cuire à 220 °C env. 40 minutes.
Faire revenir les châtaignes dans du beurre et les assaisonner. Réserver.
Quand le carré de sanglier est cuit, le retirer du plat avec les aromates et le conserver au chaud.
Amener le moût de raisin à ébullition avec le vin blanc et ajouter les sucs de cuisson de la viande. Rectifier l'assaisonnement.
Découper le carré de sanglier en huit morceaux et les déposer dans la sauce avec les châtaignes.
Servir avec des pommes de terre au romarin.

stillar de jabalí, con 8 chuletillas
y pimienta
jas de salvia
jas de laurel
nita de romero
charadas de aceite de oliva

g de castañas peladas y cocidas al vapor
charadas de mantequilla
pimienta

ml de mosto de uva
ml de vino blanco

Untar el costillar con las hierbas y el aceite de oliva y salpimentarlo. Colocarlo sobre una bandeja de horno y asarlo durante 40 minutos aprox. a 220 °C.
Saltear las castañas en mantequilla y salpimentarlas. Dejarlas aparte.
Cuando el costillar esté hecho, sacarlo de la bandeja con las hierbas y reservarlo en caliente.
Cocer el vino con el vino blanco y añadir el jugo de la bandeja de horno. Sazonar la salsa al gusto.
Cortar el costillar en ocho trozos y agregarlos con las castañas a la salsa. Se puede acompañar el plato con una guarnición de patatas al romero.

L'imbuto

Design: Carlo Pucci | Chef: Cristiano Tomei
Owners: Giuseppe Ferrara, Cristiano Tomei

Via A. Fratti, 308 Int | 55049 Viaréggio
Phone: +39 0584 48906
Opening hours: Tue, Thu–Sun lunch 12:30 pm to 3 pm, every day dinner 7:30 pm to 10 pm
Average price: € 35
Cuisine: Innovative Italian
Special features: Bread, pasta, sweets made by their own, changing exhibitions of young local artists

Tonno
con purea di fagioli

Tuna on Mashed Beans
Thunfisch auf Bohnenpüree
Thon sur sa purée de haricot
Atún sobre puré de alubias

12 cubetti di tonno di 60 g ciascuno
2 uova sbattute
Farina e pangrattato per la panatura
Sale, pepe
4 cucchiai di olio di oliva

240 g di fagioli bianchi ammorbiditi in acqua
1 piccola carota sbucciata e tagliata a dadini
½ tubero di sedano sbucciato e tagliato a dadini
½ cipolla rossa tagliata a dadini
4 foglie di salvia

½ cucchiaino di agar-agar
½ cipolla rossa
50 ml di aceto bianco
50 ml di sciroppo di zucchero
Sale, pepe

Passare con il passaverdura la cipolla con l'acet
lo sciroppo di zucchero e 50 ml d'acqua, passar
al setaccio e riscaldare un poco. Incorporar
l'agar-agar, versare il composto in un recipient
basso e lasciar rapprendere in frigorifero per circ
1 ora.
Cuocere e lasciar restringere i fagioli con la caro
ta, il sedano, la cipolla e la salvia, passarli co
il passaverdura e quindi al setaccio. Assaggiar
regolare di sale e pepe e lasciare in caldo.
Condire i cubetti di tonno, passarli nella farina
nell'uovo e quindi nel pangrattato. Scaldare l'ol
di oliva in una padella grande e friggere i cube
di tonno per circa 5 minuti finché non saran
dorati su tutti i lati.
Disporre su ogni piatto 3 cucchiai di purea
fagioli e 3 cubetti di tonno. Guarnire ogni cubet
con una striscia di gelatina.

12 tuna cubes, 2 oz each
2 eggs, whisked
Flour and breadcrumbs for breading
Salt, pepper
4 tbsp olive oil

8 ½ oz white beans, soaked
1 small carrot, peeled and diced
½ celeriac, peeled and diced
½ red onion, diced
4 sage leaves

½ tsp agar-agar
½ red onion
50 ml white vinegar
50 ml sugar syrup
Salt, pepper

Place onion, vinegar, sugar syrup and 50
water in a blender, mix, and strain warm mixtu
Stir in the agar-agar and pour mixture into
shallow dish. Refrigerate for approx. 1 hour u
thickened into a jelly.
Boil the beans with carrot, celeriac, onion a
sage, mash and put through a sieve. Season w
salt and pepper and keep warm.
Season the tuna cubes, toss in flour and eg
and bread with breadcrumbs. Heat olive oil i
large pan and fry the tuna cubes for 5 minutes
all sides until golden brown.
To serve, place 3 tbsp of mashed beans on ea
plate, put 3 tuna cubes on top and garnish ea
cube with a strip of jelly.

German

12 Thunfischwürfel á 60 g
2 Eier, verquirlt
Mehl und Semmelbrösel zum Panieren
Salz, Pfeffer
4 EL Olivenöl

240 g weiße Bohnen, eingeweicht
1 kleine Karotte, geschält und gewürfelt
1/2 Sellerieknolle, geschält und gewürfelt
1/2 rote Zwiebel, gewürfelt
4 Salbeiblätter

1/2 TL Agar-Agar
1/2 rote Zwiebel
50 ml weißer Essig
50 ml Zuckersirup
Salz, Pfeffer

Die Zwiebel mit dem Essig, Zuckersirup und 50 ml Wasser pürieren, durch ein Sieb gießen und leicht erwärmen. Das Agar-Agar einrühren, in eine flache Form geben und im Kühlschrank ca. 1 Stunde fest werden lassen.

Die Bohnen mit der Karotte, dem Sellerie, der Zwiebel und dem Salbei einkochen, pürieren und durch ein Sieb streichen. Mit Salz und Pfeffer abschmecken und warm stellen.

Die Thunfischwürfel würzen, in Mehl und Ei wenden und mit Semmelbröseln panieren. Das Olivenöl in einer großen Pfanne erhitzen und die Thunfischwürfel ca. 5 Minuten von allen Seiten goldgelb braten.

Zum Servieren 3 EL Bohnenpüree auf jeden Teller geben, 3 Thunfischwürfel darauf setzen und jeden Würfel mit einem Geleestreifen garnieren.

French

12 cubes de thon de 60 g chacun
2 œufs battus
farine et chapelure pour paner
sel, poivre
4 c. à soupe d'huile d'olive

240 g de haricots blancs détrempés
1 petite carotte épluchée en dés
1/2 céleri-rave épluché en dés
1/2 oignon rouge en dés
4 feuilles de sauge

1/2 c. à café d'agar-agar
1/2 oignon rouge
50 ml de vinaigre blanc
50 ml de sirop de sucre
sel, poivre

Réduire l'oignon en purée avec le vinaigre, le sirop de sucre et 50 ml d'eau, passer au chinois et réchauffer légèrement. Délayer l'agar-agar, verser dans un moule plat et laisser prendre au réfrigérateur env. 1 heure.

Faire cuire les haricots avec la carotte, le céleri, l'oignon et la sauge; réduire en purée et passer au chinois. Saler, poivrer et conserver au chaud.

Assaisonner les cubes de thon, les rouler dans la farine et l'œuf et les paner avec la chapelure. Réchauffer l'huile d'olive dans une grande poêle et faire dorer les cubes de thon sur toutes les faces pendant env. 5 minutes.

Pour servir, disposer 3 c. à soupe de purée de haricot sur chaque assiette, déposer dessus 3 cubes de thon et garnir chaque cube d'une lamelle de gelée.

Spanish

12 daditos de atún de unos 60 g
2 huevos batidos
harina y pan rallado para empanar
sal y pimienta
4 cucharadas de aceite de oliva

240 g de alubias blancas en remojo
1 zanahoria pequeña pelada y troceada
1/2 manojo de apio pelado y troceado
1/2 cebolla roja troceada
4 hojas de salvia

1/2 cucharadita de Agar-Agar
1/2 cebolla roja
50 ml de vinagre blanco
50 ml de sirope de azúcar
sal y pimienta

Hacer un puré con la cebolla, el vinagre, el sirope y 50 ml de agua. Pasarlo por un colador y calentarlo ligeramente. Agregarle el Agar-Agar, extenderlo en un molde plano y dejar que se endurezca en el frigorífico durante 1 hora aprox.

Cocer las zanahorias con el apio, la cebolla y la salvia. Hacerlo puré y colarlo. Salpimentarlo y reservarlo en caliente.

Salpimentar los daditos de atún, rebozarlos en harina y huevo y empanarlos con el pan rallado. Calentar el aceite de oliva en una sartén grande y freír los daditos de atún hasta que estén dorados por cada lado durante 5 minutos aprox.

Servir poniendo 3 cucharadas de puré de alubias en cada plato, 3 daditos de atún encima y decorar cada dadito con una tira de gelatina.

Locanda Caino

Design: Clara Dovizia, Maurizio Memichetti | Chefs: Valeria Piccini, Andrea Menichetti | Owner: Menichetti Family

Via della Chiesa, 4 | 58050 Montemerano
Phone: +39 0554 602817
www.dacaino.it
Opening hours: Every day lunch 12:30 pm to 2 pm, dinner 7:30 pm to 9 pm
Menu price: € 90
Cuisine: Tuscan

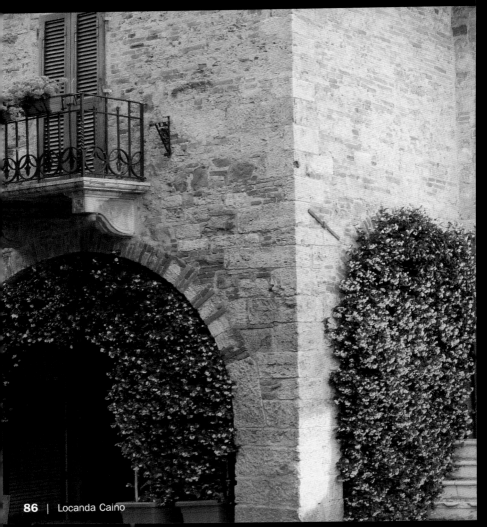

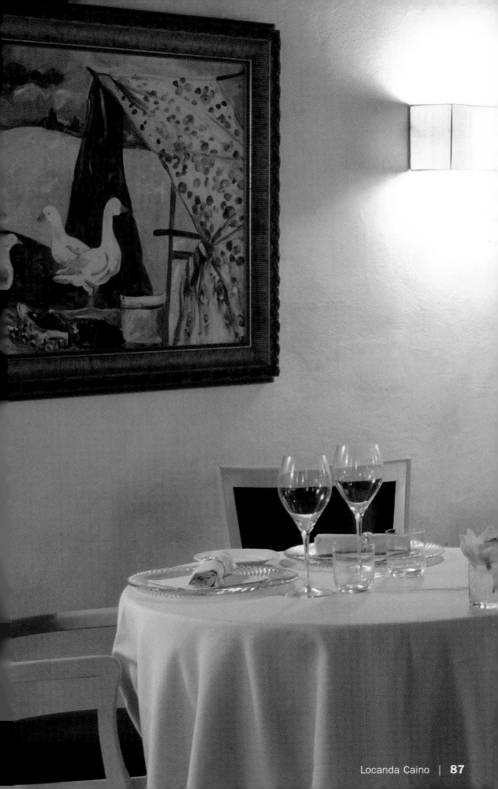

Lorenzo

Design: Torri Bianca Maria | Chef: Gioacchino Pomtrelli
Owner: Lorenzo Viani

Via G. Carducci, 61 | 55042 Forte dei Marmi
Phone: +39 0584 874030
Opening hours: Sep to Jun Tue–Sun dinner 8 pm to 10:30 pm, Jul & Aug every day
lunch 12:30 pm to 2:30 pm, dinner 8 pm to 10:30 pm, holidays mid of Dec until
end of Jan
Menu price: € 80–90
Cuisine: Classical, innovative

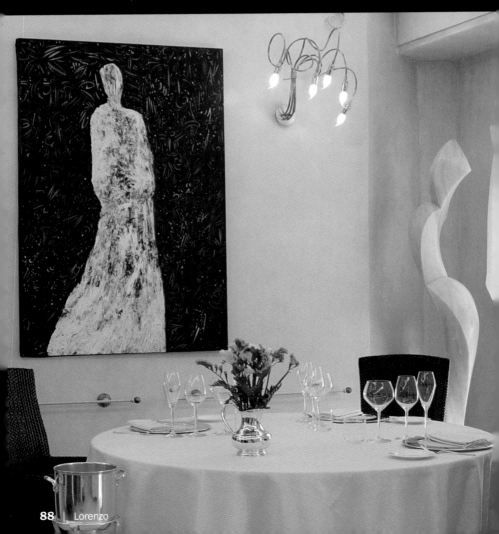

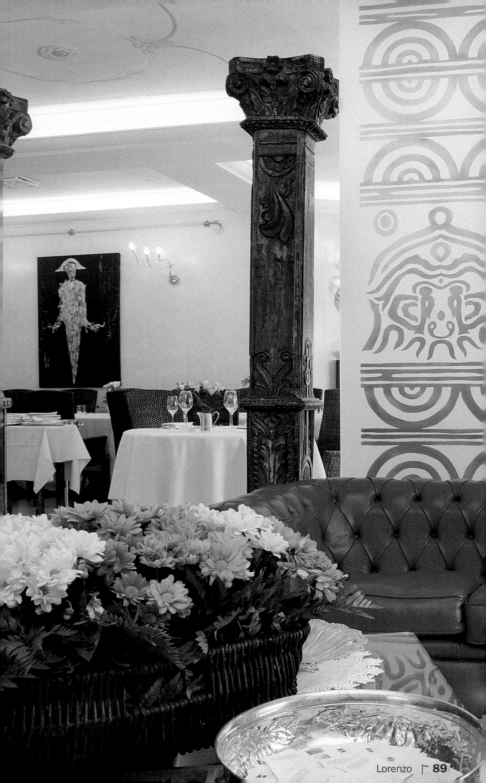

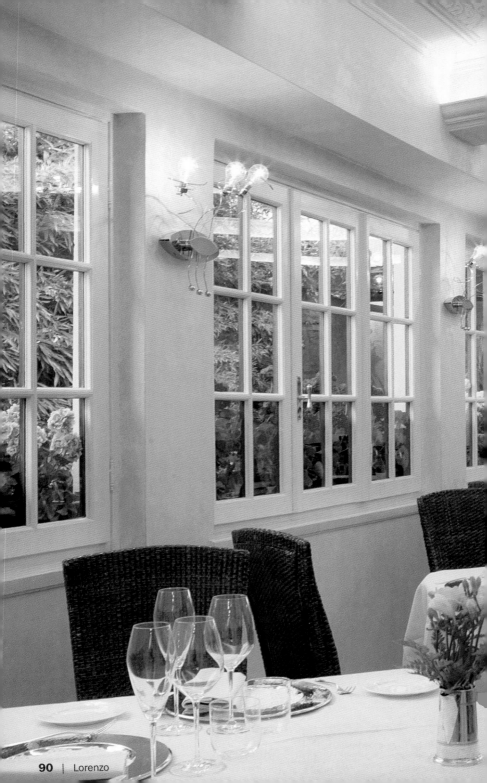

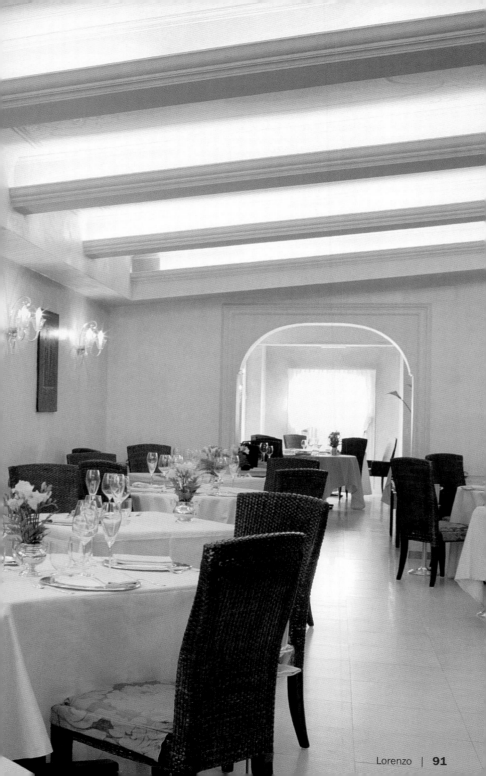

Pesce San Pietro
con verdure primaverili

John Dory with Spring Vegetables
Sankt Petersfisch mit Frühlingsgemüse
Saint-Pierre aux légumes printaniers
San Pedro con verdura de primavera

12 pezzi di pesce San Pietro di 60 g ciascuno
3 cucchiai di burro
Sale, pepe nero

1 carota sbucciata e tagliata a dadini
1 gambo di sedano tagliato a fette
½ cipolla tagliata a dadini
2 pomodori spellati e spezzettati
3 cucchiai di aceto di vino bianco
2 cucchiai di olio di oliva
1 cucchiaino di senape
Sale, pepe

4 foglie di menta

Scottare in acqua salata bollente la carota
sedano, passarli sotto l'acqua fredda e tene
parte. Preparare una vinaigrette con aceto,
senape, sale e pepe, unire le verdure, i pom
e la cipolla e lasciar marinare.
Insaporire il pesce con il sale e il pepe ne
rosolarlo nel burro caldo da entrambi i lati
3 minuti.
Disporre su ogni piatto tre tranci di pesce,
mando una stella, ricoprirli con le verdure r
nate e guarnire con le foglie di menta.

12 pieces John Dory, 2 oz each
3 tbsp butter
Salt, black pepper

1 carrot, peeled and diced
1 celery, in slices
½ onion, diced
2 tomatoes, skinned and diced
3 tbsp white wine vinegar
2 tbsp olive oil
1 tsp mustard
Salt, pepper

4 mint tips

Blanch the carrot and celery in salted water,
and set aside. Make a vinaigrette out of vine
oil, mustard, salt and pepper. Stir in the
etables, tomatoes and onion into the vinaigr
and marinate.
Season the fish with salt and black pepper.
fish in hot butter for 3 minutes on each side
Place three pieces of fish in a star shape on
plate, cover with the marinated vegetables
garnish with mint tips.

12 Stücke Sankt Petersfisch, à 60 g
3 EL Butter
Salz, schwarzer Pfeffer

1 Karotte, geschält und gewürfelt
1 Stange Staudensellerie, in Scheiben
½ Zwiebel, gewürfelt
2 Tomaten, gehäutet und gewürfelt
3 EL Weißweinessig
2 EL Olivenöl
1 TL Senf
Salz, Pfeffer

4 Minzspitzen

Karotte und Staudensellerie in Salzwasser blanchieren, abschrecken und beiseite stellen. Aus Essig, Öl, Senf, Salz und Pfeffer eine Vinaigrette bereiten, das Gemüse, die Tomaten und die Zwiebel unterrühren und marinieren lassen.
Den Fisch mit Salz und schwarzem Pfeffer würzen, und in heißer Butter von beiden Seiten 3 Minuten braten.
Jeweils drei Stücke Fisch sternförmig auf einem Teller anrichten, mit dem marinierten Gemüse bedecken und mit je einer Minzspitze garnieren.

12 morceaux de Saint-Pierre de 60 g chacun
3 c. à soupe de beurre
sel, poivre noir

1 carotte épluchée en dés
1 branche de céleri branche en tranches
½ oignon en dés
2 tomates pelées en dés
3 c. à soupe de vinaigre de vin blanc
2 c. à soupe d'huile d'olive
1 c. à café de moutarde
sel, poivre

4 feuilles de menthe

Blanchir la carotte et le céleri dans de l'eau salée, égoutter, passer sous l'eau froide et réserver.
Préparer une vinaigrette avec le vinaigre, l'huile, la moutarde, le sel et le poivre. Y ajouter les légumes, les tomates et l'oignon et laisser mariner.
Assaisonner le poisson aux sel et poivre noir et cuire dans le beurre chaud 3 minutes des deux côtés.
Déposer trois morceaux de poisson en étoile sur chaque assiette, couvrir de légumes marinés et garnir d'une feuille de menthe.

12 trozos de San Pedro de 60 g
3 cucharadas de mantequilla
sal y pimienta negra

1 zanahoria pelada y troceada
1 manojo de apio en rodajas
½ cebolla troceada
2 tomates pelados y troceados
3 cucharadas de vinagre de vino blanco
2 cucharadas de aceite de oliva
1 cucharadita de mostaza
sal y pimienta

4 puntas de menta

Escaldar la zanahoria y el apio en agua salada, pasarlos por agua fría y reservarlos aparte.
Preparar una vinagreta a base de vinagre, aceite, mostaza, sal y pimienta, agregarle la verdura, los tomates y la cebolla y dejar en marinado.
Sazonar el pescado con la sal y la pimienta negra y freírlo por ambos lados en mantequilla caliente durante 3 minutos.
Colocar en cada plato tres trozos de pescado formando una estrella, cubrirlos con la verdura y coronarlos con una punta de menta.

Osteria da Tronca

Design: Maudi Pugi, Fiorenzo Borelli | Chef: Giancarlo Venturi
Owners: Giancarlo Venturi, Moreno Venturi, Enzo Congiu

Vicolo Porte, 5 | 58024 Massa Marittima
Phone: +39 0566 901991
Opening hours: Thu–Tue dinner 6 pm to midnight, kitchen open 7 pm to 10 pm,
closed on Wed, holidays mid of Dec until beginning of Mar
Average price: € 25
Cuisine: Typical Maremma
Special features: All dishes by old family recipes

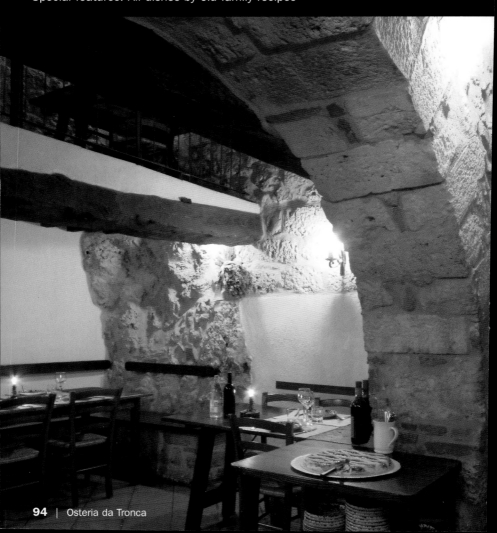

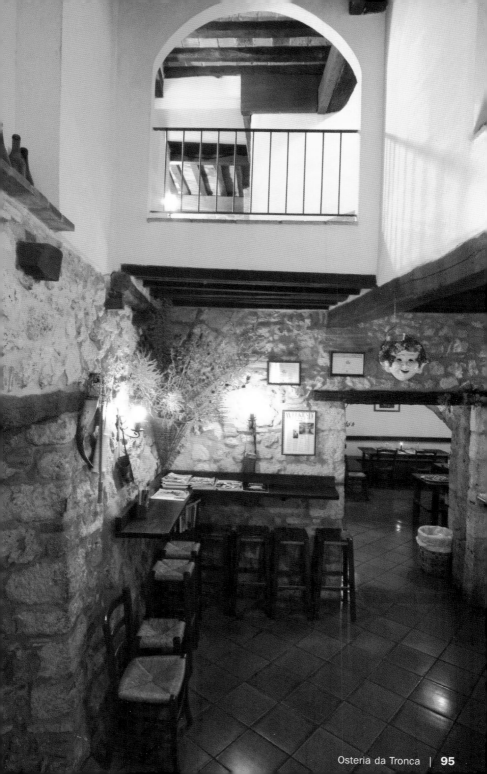

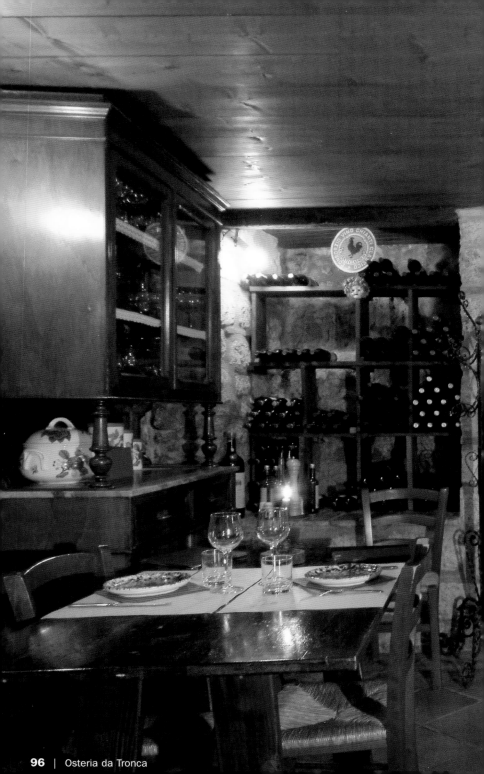

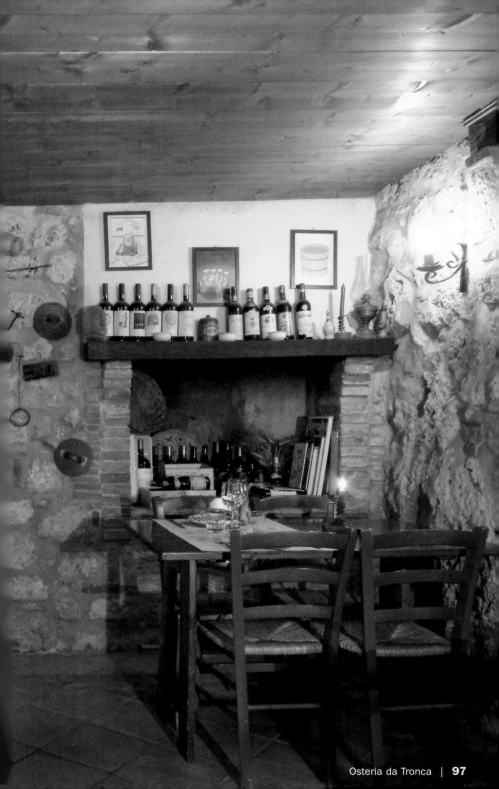

Osteria di Passignano

Design: Allegra Antinori | Chefs: Matia Barciulli, Nicola Damiani
Owner: Marcello Crini

Via Passignano, 33 | Loc. Badia a Passignano | 50028 Tavarnelle Val di Pesa
Phone: +39 055 8071278
www.osteriadipassignano.com
Opening hours: Every day lunch 12:15 pm to 2:15 pm, dinner 7:30 pm to 10 pm,
closed on Sun
Average price: € 50
Cuisine: Reinvention of Tuscan kitchen
Special features: All dishes by family recipes

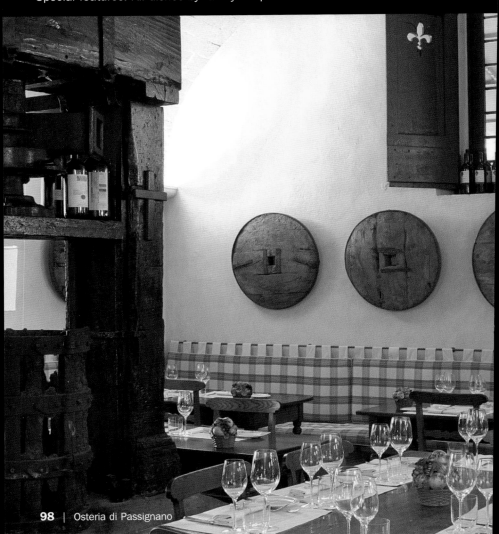

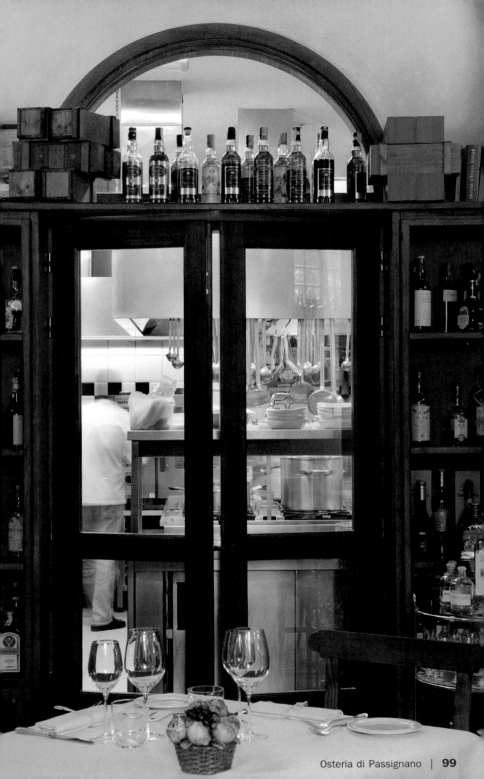

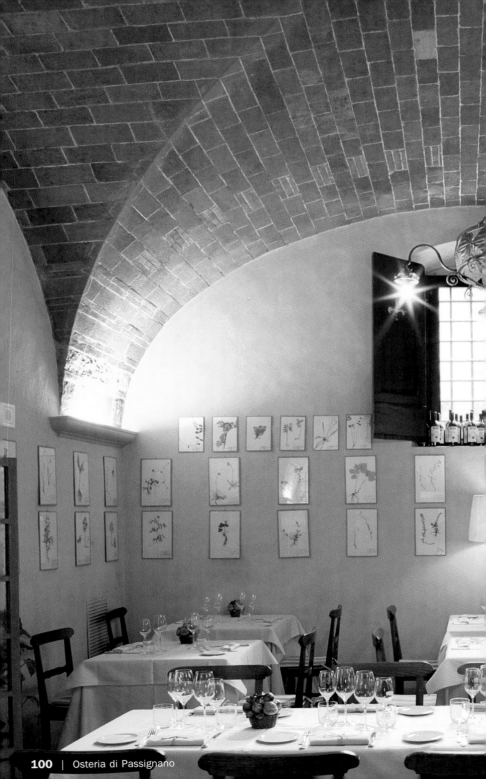

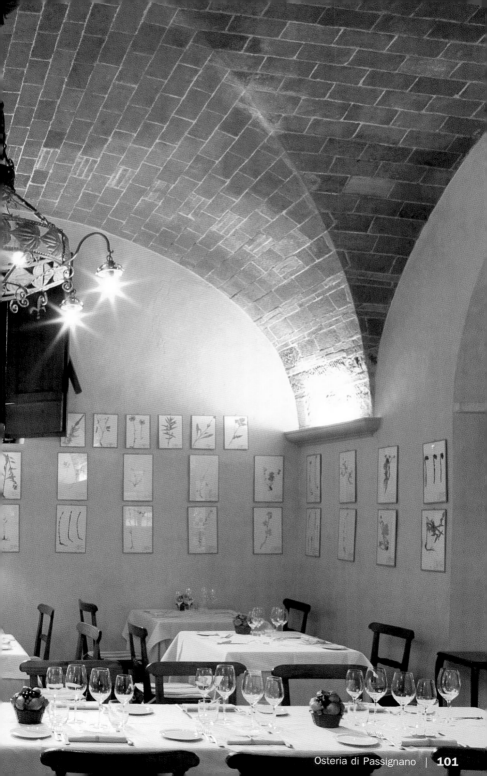

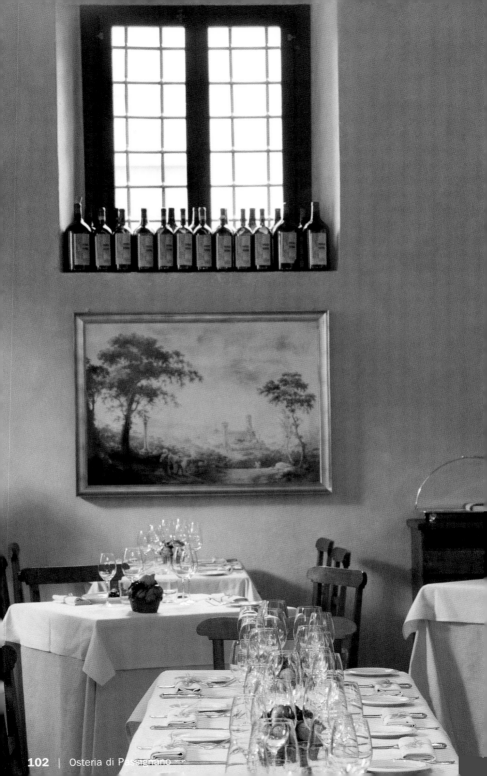

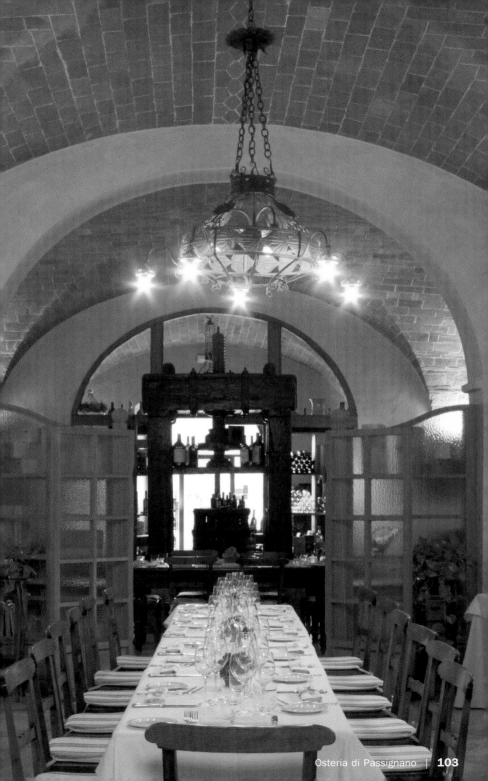

Petto e coscia

di piccione con scalogni e ciliegie candite

Breast and Leg of a Pigeon with Shallots and Candied Cherries

Brust und Schlegel von der Taube mit Schalotten und kandierten Kirschen

Filets et cuisses de pigeon aux échalotes et cerises confites

Pechuga y muslo de paloma con chalotas y cerezas confitadas

4 piccioni
4 fogli di pasta fillo (dimezzati)
4 cucchiai di olio di oliva

16 scalogni
2 cucchiai di zucchero bruno
4 ramoscelli di timo
300 ml di vino rosso
Sale, pepe

8 ciliegie candite (con sciroppo)
Per la guarnizione: ramoscelli di timo e ribes rossi

Caramellizzare lo zucchero bruno in un pentolino, quindi unirvi gli scalogni sbucciati, bagnare con il vino rosso e aggiungere il timo. Lasciar cuocere per circa 15 minuti.

Disossare i piccioni, dividendo i fegatini, i petti le cosce. Con le ossa, preparare una salsa.
Tritare finemente i fegatini, condirli e farcire cosce con il composto ottenuto. Salare, pepa ed arrotolare mezzo foglio di pasta fillo attorno ogni coscia. Cuocere le cosce in forno per cir 15 minuti a 180 °C, finché la pasta sarà dorat Far rosolare i petti da ambo le parti a fuoco vi e metterli in forno con le cosce durante gli ulti 4 minuti.
Distribuire gli scalogni su quattro piatti, dispo intorno i petti e le cosce e guarnire con le cilieg candite e i ramoscelli di timo. Pillottare con sal di piccione, sciroppo di ciliegia e olio di oliva.

4 pigeons
4 sheets filo dough, halved
4 tbsp olive oil

16 shallots
2 tbsp brown sugar
4 twigs thyme
300 ml red wine
Salt, pepper

8 candied cherries (and syrup)
Thyme twigs and red currants for decoration

Caramelize brown sugar in a small pot. Peel the shallots and place in the pot, deglaze with red wine and add thyme. Cook for 15 minutes.

Draw the pigeons; separate the livers, breas and legs. Make a sauce out of the bones.
Mince the pigeon livers, season with salt a pepper, and stuff the legs with the liver past Season legs with salt and pepper and wrap each into a halved filo sheet. Bake the legs at 360 °F approx. 15 minutes, until the dough turns ligh brown.
Sear the breasts from both sides and put in t oven with the legs for the last 4 minutes.
Divide the shallots onto four plates, arrange t breasts and legs around them and garnish wi candied cherries and thyme twigs. Drizzle wi pigeon sauce, cherry syrup and olive oil.

4 Tauben
4 Blätter Filoteig, halbiert
4 EL Olivenöl

16 Schalotten
2 EL brauner Zucker
4 Zweige Thymian
300 ml Rotwein
Salz, Pfeffer

8 kandierte Kirschen (und Sirup)
Thymianzweige und rote Johannisbeeren zur
Dekoration

Den braunen Zucker in einem kleinen Topf kara-
mellisieren lassen, die Schalotten schälen und
zugeben, mit Rotwein ablöschen und den Thymian
zufügen. Ca. 15 Minuten kochen lassen.

Die Tauben auslösen, dabei die Lebern, Brüste
und Schlegel trennen. Aus den Knochen eine
Sauce kochen.
Die Lebern fein hacken, würzen und die Schlegel
mit der Leberpaste füllen. Salzen und pfeffern
und je einen Schlegel in ein halbes Filoblatt
wickeln. Die Schlegel bei 180 °C ca. 15 Minuten
backen, bis der Teig leicht bräunt.
Die Brüste von beiden Seiten scharf anbraten und
während der letzten 4 Minuten zu den Schlegeln
geben.
Die Schalotten auf vier Tellern verteilen, die
Brüste und Schlegel darum setzen und mit
kandierten Kirschen und Thymianzweigen garnie-
ren. Mit Taubensauce, Kirschsirup und Olivenöl
beträufeln.

4 pigeons
4 feuilles de pâte filo, coupées en deux
4 c. à soupe d'huile d'olive

16 échalotes
c. à soupe de sucre brun
branches de thym
300 ml de vin rouge
sel, poivre

cerises confites (avec du sirop)
branches de thym et groseilles rouges pour la
décoration

Caraméliser le sucre brun dans une petite cas-
serole, éplucher les échalotes, les ajouter au
caramel, déglacer avec le vin rouge et ajouter le
thym. Laisser réduire env. 15 minutes.

Désosser les pigeons et détailler les foies, les
filets et les cuisses. Préparer une sauce avec
les os.
Hacher menu les foies, les assaisonner et en far-
cir les cuisses. Saler et poivre; enrouler chaque
cuisse dans une demie feuille de pâte filo. Les
cuire au four à 180 °C env. 15 minutes jusqu'à
ce que la pâte soit dorée.
Saisir les filets à la poêle des deux côtés et les
ajouter aux cuisses pour les 4 dernières minutes
de cuisson.
Répartir les échalotes dans quatre assiettes,
dresser les cuisses et les filets autour et garnir
avec les cerises confites et les branches de thym.
Arroser de sauce de pigeon, de sirop de cerise et
d'huile d'olive.

palomas
planchas de pasta filo, cortadas a la mitad
cucharadas de aceite de oliva

6 chalotas
cucharadas de azúcar moreno
ramitas de tomillo
300 ml de vino tinto
sal y pimienta

cerezas confitadas (y su almíbar)
ramitas de tomillo y grosellas rojas para decorar

Caramelizar el azúcar moreno en una cazuela
pequeña, pelar las chalotas y añadirlas al azú-
car, rociarlas con vino tinto y agregar el tomillo.
Ahogar durante unos 15 minutos aprox.

Deshuesar las palomas, y separar los hígados,
las pechugas y los muslos. Hacer una salsa con
los huesos.
Picar muy finos los hígados, sazonarlos y rellenar
los muslos con ellos. Salpimentar y enrollar cada
muslo en media plancha de pasta filo. Cocer
los muslos en el horno durante unos 15 minu-
tos aprox. a 180 °C, hasta que la masa esté
dorada.
Freír bien las pechugas por ambos lados y agre-
garlas a los muslos durante los últimos 4 minutos
de horno.
Disponer las chalotas en cuatro platos, colocar
las pechugas y los muslos y decorarlos con las
cerezas confitadas y las ramitas de tomillo. Rociar
todo con la salsa de paloma, el almíbar de cereza
y aceite de oliva.

Osteria la Solita Zuppa

Chefs, Owners: Roberto Pacchieri, Luana Pacchieri

Via Porsenna, 21 | 53043 Chiusi
Phone: +39 0578 21006
www.lasolitazuppa.it
Opening hours: Every day lunch 12:30 pm to 2:30 pm, dinner 7:30 pm to 10 pm, closed on Tue, holidays mid of Jan until beginning of Mar
Average price: € 30
Cuisine: Tuscan

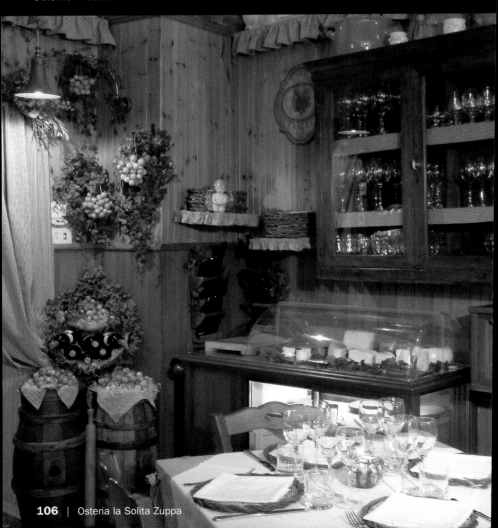

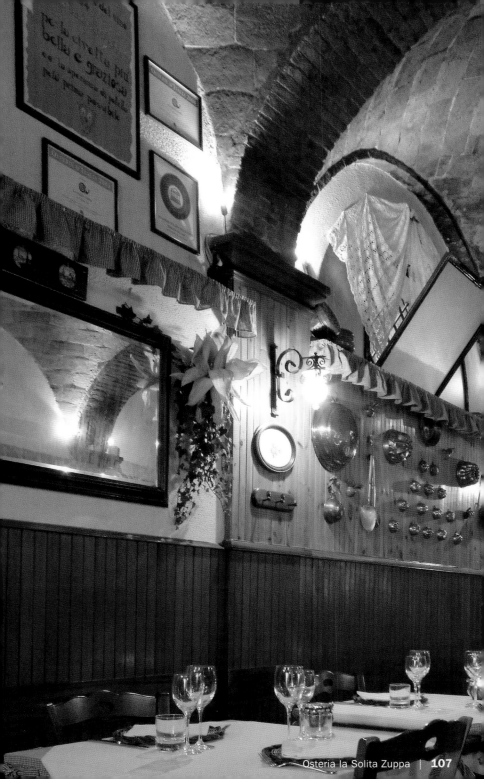

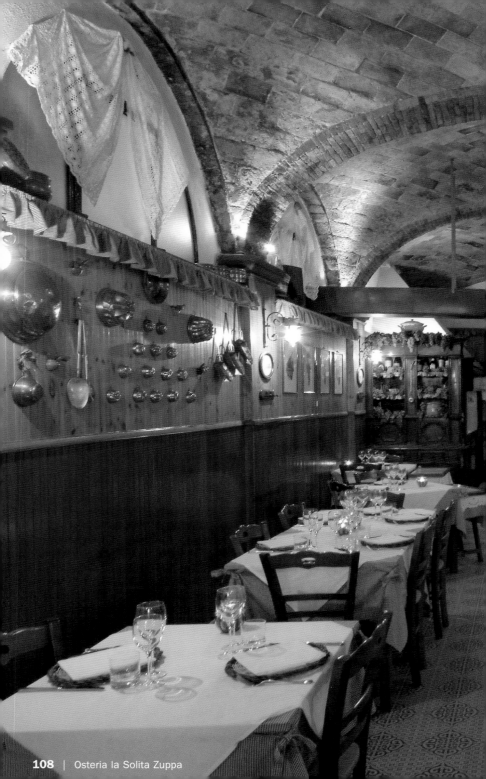

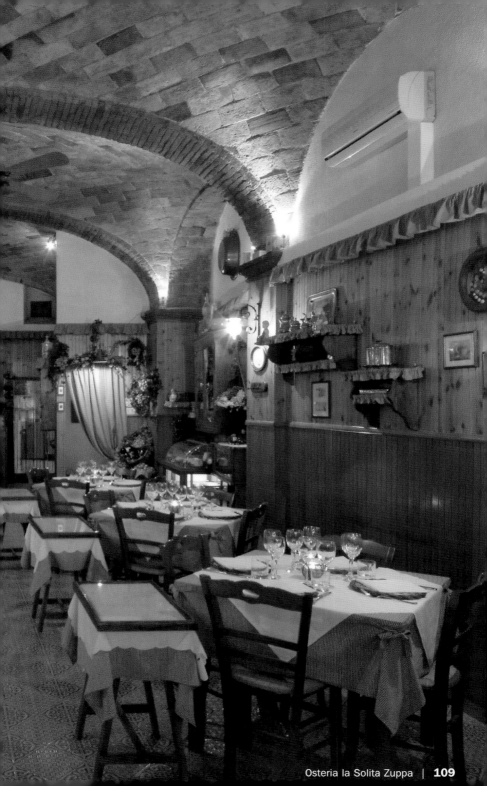

Pici con aglio

Pici with Garlic
Pici mit Knoblauch
Pici à l'ail
Pici con ajo

300 g di farina
3 uova
3 cucchiai d'acqua
1 presa di sale

3 spicchi d'aglio tritati
3 cucchiai di olio di oliva
6 pomodori grossi, spellati e spezzettati
Sale, pepe, zucchero, paprika

Preparare una pasta sfoglia morbida con fa
na, uova, acqua e sale e lasciarla riposare
30 minuti.
In una padella, rosolare l'aglio nell'olio di oli
aggiungere i pomodori spezzettati e condire c
sale, pepe, zucchero e paprika. Cuocere a fuc
lento per 20 minuti.
Stendere la pasta in una sfoglia spessa 1 c
tagliarla in strisce sottili e formare con le m
degli spaghetti di forma irregolare. Cuocere i
per circa 4 minuti in abbondante acqua sala
quindi estrarli e versarli nella salsa in pade
Saltare la pasta nella salsa, assaggiare ed ev
tualmente regolare il condimento

10 ½ oz flour
3 eggs
3 tbsp water
1 pinch salt

3 cloves of garlic, chopped
3 tbsp olive oil
6 large tomatoes, skinned and diced into cubes
Salt, pepper, sugar, paprika powder

Make a flexible pasta dough out of flour, eg
water and salt. Let it rest for 30 minutes.
Sauté garlic in a pan in olive oil, add the tom
cubes and season with salt, pepper, sugar a
paprika powder. Let it simmer for 20 minutes.
Flatten the dough to ½ inch thickness, cut in t
stripes and shape into long noodles with y
hands. Cook in plenty of salted water for app
4 minutes. Drain the noodles and put into
pan with the sauce. Toss the noodles in the sa
and season if necessary.

300 g Mehl
3 Eier
3 EL Wasser
1 Prise Salz

3 Knoblauchzehen, gehackt
3 EL Olivenöl
6 große Tomaten, gehäutet und gewürfelt
Salz, Pfeffer, Zucker, Paprikapulver

Aus Mehl, Eiern, Wasser und Salz einen geschmeidigen Pastateig bereiten. 30 Minuten ruhen lassen.
Den Knoblauch in einer Pfanne in Olivenöl anbraten, die Tomatenwürfel zugeben und mit Salz, Pfeffer, Zucker und Paprikapulver würzen. Für 20 Minuten leise köcheln lassen.
Den Teig 1 cm dick ausrollen, in dünne Streifen schneiden und mit den Händen lange Nudeln daraus formen. In viel kochendem Salzwasser ca. 4 Minuten gar ziehen lassen. Die Nudeln herausnehmen und zu der Sauce in die Pfanne geben. Die Nudeln in der Sauce schwenken und evtl. noch mal abschmecken.

300 g de farine
3 œufs
3 c. à soupe d'eau
1 pincée de sel

3 gousses d'ail hachées
3 c. à soupe d'huile d'olive
6 grosses tomates pelées en dés
sel, poivre, sucre, poudre de paprika

Préparer une pâte souple avec la farine, les œufs, l'eau et le sel. Laisser reposer 30 minutes.
Dans une poêle, faire revenir l'ail dans l'huile d'olive, ajouter la concassée de tomates et assaisonner de sel, poivre, sucre et poudre de paprika. Laisser cuire à petits frémissements pendant 20 minutes.
Etaler la pâte sur 1 cm d'épaisseur, la couper en fines lamelles et travailler à la main pour leur donner la forme de longues ficelles. Les faire cuire dans beaucoup d'eau salée bouillante env. 4 minutes. Egoutter les pâtes; les ajouter à la sauce et poêler le tout. Rectifier l'assaisonnement si nécessaire.

300 g de harina
3 huevos
3 cucharadas de agua
1 pizca de sal

3 dientes de ajo picados
3 cucharadas de aceite de oliva
6 tomates grandes pelados y troceados
sal, pimienta, azúcar y pimentón

Hacer una masa suave de pasta con la harina, los huevos, agua y sal. Dejarla reposar durante 30 minutos.
Sofreír el ajo en una sartén con aceite de oliva, añadir los tomates troceados y sazonarlos con sal, pimienta, azúcar y pimentón. Rehogarlos a fuego lento durante 20 minutos.
Extender la masa con un grosor de 1 cm, cortarla en tiras finas y con la mano moldearlas en forma alargada. Cocerlas en abundante agua salada durante unos 4 minutos aprox. Sacar la pasta y añadirla a la salsa en la sartén. Saltearla y si es necesario sazonarla de nuevo.

Parodi Locanda del Castellano

Design, Chef: Silvana Stazio | Owner: Daniele Parodi

Via Borgo Diritto, 59 | 54010 Caprigliola, Aulla
Phone: +39 0187 415547
www.ristoranteparodi.com
Opening hours: Sep to Jun Sat–Sun lunch 1 pm to 3 pm, dinner 8 pm to midnight,
Wed–Fri dinner 8 pm to midnight, closed Mon & Tue, Jul & Aug every day lunch
1 pm to 3 pm, dinner 8 pm to midnight
Average price: € 70
Cuisine: Creative

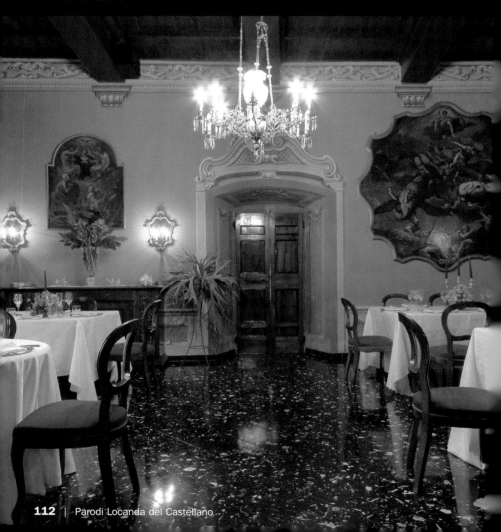

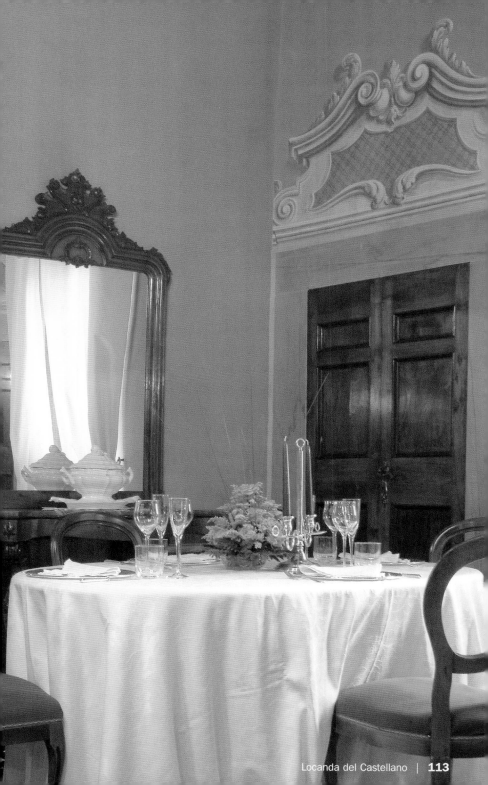

Lasagne
con scampi e pomodori

Lasagna with Scampi and Tomatoes
Lasagne mit Scampi und Tomaten
Lasagne aux scampis et tomates
Lasaña con langostinos y tomates

300 g di crusca di frumento
100 g di farina
6 tuorli d'uovo
1 uovo intero
1 presa di sale
1 cucchiaio di olio di oliva

20 scampi (16 svuotati, 4 non svuotati)
2 cucchiai di olio di oliva
½ spicchio d'aglio tritato
8 pomodori grossi spellati e spezzettati
Sale, pepe
1 confezione da 250 g di pesto alla genovese

Lavorare gli ingredienti per la pasta. Lasciare in fresco per 30 minuti.
Rosolare l'aglio nell'olio di oliva, aggiungere i pomodori spezzettati e farli restringere bene. Condire.

Stendere la pasta in una sfoglia sottile e, l'aiuto di una formina rotonda, ricavarne forme circolari del diametro di 7 cm cia na. Scottarle in acqua salata bollente per c 2 minuti, passarle sotto l'acqua fredda ed as garle tamponando. Incidere profondamente dorso i 16 scampi svuotati, ma in modo che si stacchino (taglio a farfalla).
Imburrare quattro anelli di metallo del diametr 7 cm e disporre in ognuno di essi a strati alter 1 sfoglia di pasta, 1 scampo, 1 cucchiaio di s di pomodoro e 1 cucchiaino di pesto. Termir con una sfoglia di pasta e ricoprire con 1 c chiaio di salsa di pomodoro. Cuocere in forr 200 °C per circa 7 minuti.
Guarnire il piatto alternando pesto e salsa pomodoro, porre sul piatto una sfoglia di pa e completare la decorazione con uno sca intero.

10 ½ oz wheat spelt
3 ½ oz flour
6 egg yolks
1 egg
1 pinch salt
1 tbsp olive oil

20 scampi (16 cleaned, 4 whole scampi)
2 tbsp olive oil
½ clove of garlic, chopped
8 large tomatoes, skinned and diced
Salt, pepper
9 oz-glass green pesto

Combine the ingredients for the dough and refrigerate for 30 minutes.
Sauté garlic in olive oil, add in the tomato cubes

and simmer until fully cooked. Season with and pepper.
Flatten the pasta dough until very thin and cu lasagna sheets with a diameter of 3 inches a circular cookie cutter. Boil in salted wate approx. 2 minutes. Dry off pieces and chill. the 16 scampi lengthwise in half, so that they still connected (butterfly cut).
Grease four metal rings (diameter of 3 inch Place a layer of 1 lasagna sheet, 1 sca 1 tbsp tomato sauce, and 1 tsp pesto 4 ti after each other in the rings. Finish with a lasa sheet and cover with 1 tbsp of tomato sa Bake at 390 °F for approx. 7 minutes.
To serve, decorate the plate with tomato sa and pesto, place one lasagna on the plate garnish with a whole scampi.

Weizenkleie / Mehl (German)

00 g Weizenkleie
.00 g Mehl
 Eigelbe
. Ei
. Prise Salz
. EL Olivenöl

0 Scampi (16 ausgelöst, 4 unausgelöst)
 EL Olivenöl
2 Knoblauchzehe, gehackt
 große Tomaten, gehäutet und gewürfelt
alz, Pfeffer
 Glas grüne Pesto (250 g)

ie Zutaten für den Teig verkneten, 30 Minuten
altstellen.
en Knoblauch in Olivenöl anschwitzen, die
matenwürfel zugeben und einkochen lassen.
ürzen.

Den Pastateig dünn ausrollen und mit einem runden Ausstecher mit einem Durchmesser von 7 cm 20 Lasagneplatten ausstechen. In Salzwasser ca. 2 Minuten blanchieren, abschrecken und trocken tupfen. Die 16 ausgelösten Scampi längs halbieren, so dass sie trotzdem noch zusammenhängen (Schmetterlingsschnitt).

Vier Metallringe (Durchmesser 7 cm) fetten und je viermal abwechselnd 1 Lasagneplatte, 1 Scampi, 1 EL Tomatensauce und 1 TL Pesto einschichten. Mit einer Lasagneplatte abschließen und mit 1 EL Tomatensauce bedecken. Bei 200 °C ca. 7 Minuten im Ofen backen.

Zum Servieren den Teller abwechselnd mit Pesto und Tomatensauce dekorieren, eine Lasagne auf den Teller setzen und mit einem ganzen Scampi garnieren.

00 g de son de blé
00 g de farine
 jaunes d'œuf
 œuf
 pincée de sel
c. à soupe d'huile d'olive

 scampis (16 décortiqués et 4 non décortiqués
 mettre de côté)
c. à soupe d'huile d'olive
 gousse d'ail haché
 grosses tomates pelées en dés
l, poivre
pot de 250 g de pesto vert

 alaxer les ingrédients pour la pâte et mettre au
 is 30 minutes.
 re fondre l'ail dans l'huile d'olive, ajouter les
 s de tomate et faire cuire. Assaisonner.

Etaler la pâte à lasagne assez finement et découper avec un emporte-pièce rond de 7 cm de diamètre 20 feuilles de lasagne. Les blanchir dans de l'eau salée env. 2 minutes, les égoutter, les passer sous l'eau froide et les sécher. Couper les 16 scampis décortiqués dans le sens de la longueur, mais de façon qu'ils se tiennent encore (coupe papillon).

Beurrer quatre anneaux métalliques (7 cm de diamètre) et déposer dans chacun alternativement 1 feuille de lasagne, 1 scampi, 1 c. à soupe de sauce tomate et 1 c. à café de pesto. Terminer par une feuille de lasagne et recouvrir d'1 c. à soupe de sauce tomate. Cuire au four à 200 °C env. 7 minutes.

Pour servir, décorer l'assiette alternativement de pesto et de sauce tomate, déposer une lasagne sur l'assiette et garnir d'un scampi entier.

0 g de salvado de trigo
0 g de harina
 emas de huevo
 uevo
 izca de sal
 ucharada de aceite de oliva

 langostinos (16 pelados, 4 sin pelar)
 ucharadas de aceite de oliva
 diente de ajo picado
 omates grandes pelados y troceados
 y pimienta
 ote de 250 g de pesto verde

 asar los ingredientes para la pasta y reservar
 nasa en frío durante 30 minutos.
 reír el ajo en aceite de oliva, añadirle los tro-
 de tomate, rehogarlos y sazonarlos.

Extender la masa para pasta y con un cortador circular cortar 20 trozos de 7 cm de diámetro. Escaldarlos en agua salada durante 2 minutos, pasarlos por agua fría y secarlos. Abrir longitudinalmente los 16 langostinos pelados sin separar del todo las mitades (corte mariposa).

Untar de grasa cuatro anillos de metal (de 7 cm de diámetro) colocar respectivamente 1 plancha de lasaña, 1 langostino, 1 cucharada de salsa de tomate y 1 cucharadita de pesto, hasta completar cuatro capas. Colocar en cada última capa 1 plancha de lasaña y cubrirla con 1 cucharada de salsa de tomate. Cocinar en el horno durante 7 minutos aprox. a 200 °C.

Para servir decorar cada plato intercalando pesto y salsa de tomate, disponer una lasaña en el plato y adornar con un langostino sin pelar.

Romano

Design: Studio tecnico Vannini e Malfatti | Chef: Franca Checchi
Owners: Romano Franceschini & Family

Via Mazzini, 120 | 55049 Viareggio
Phone: +39 0584 31382
www.romanoristorante.it
Opening hours: Every day lunch noon to 2:45 pm, dinner 7:30 pm to 10:45 pm
Average price: € 60–75
Cuisine: Mediterranean with fish

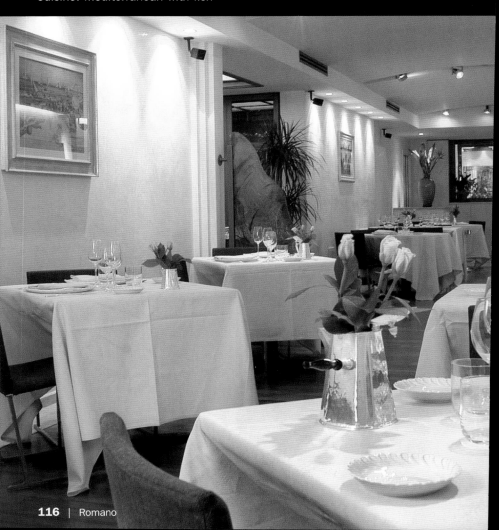

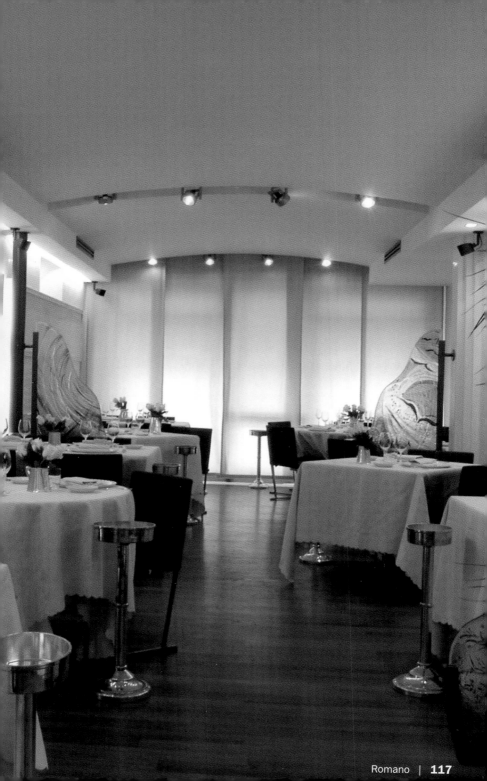

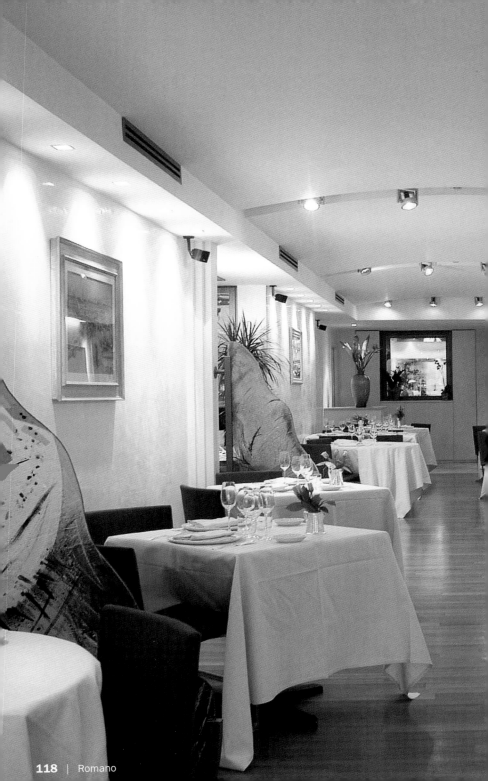

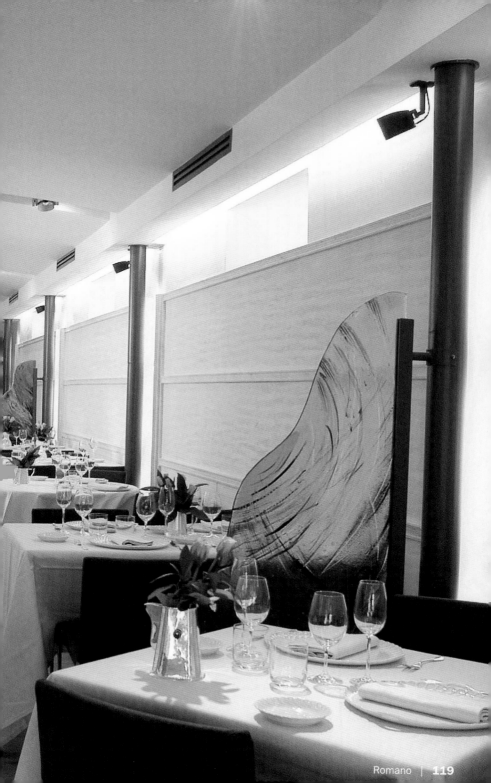

Calamari ripieni

Stuffed Calamaretti

Gefüllte Calamaretti

Calamaretti farcis

Calamaretti rellenos

16 calamari puliti

2 carote sbucciate e tagliate a dadini
2 zucchini tagliati a dadini
La polpa della coda di 8 gamberi
3 cucchiai di olio di oliva
1 spicchio d'aglio tritato
½ peperoncino tritato
Sale, pepe
1 fetta di pane bianco tagliata a dadini
1 uovo
2 cucchiai di basilico tritato

Rosolare le carote e gli zucchini nell'olio di oli
unirvi la polpa di gambero e continuare a rosola
per 4 minuti. Aggiungere l'aglio e il peperoncir
salare e pepare. Unire il pane e l'uovo e frulla
brevemente. Il composto deve contenere anc
dei pezzi interi. Unire il basilico, assaggiare e,
necessario, regolare il condimento.
Riempire il mantello dei calamari con l'impas
chiudere con uno stecchino e disporre i calam
in una pirofila. Salare, pepare e pillottare c
poco olio di oliva. Cuocere in forno a 200 °C ¡
circa 10 minuti.

16 calamaretti, cleaned

2 carrots, peeled and diced
2 zucchini, diced
8 prawns, only the tail meat
3 tbsp olive oil
1 clove of garlic, chopped
½ chili, chopped
Salt, pepper
1 slice white bread, diced
1 egg
2 tbsp basil, chopped

Sauté carrots and zucchini in olive oil, add
prawn meat and sear for 4 minutes. Put mixt
into a blender with garlic, chili, salt and pep
and blend together until coarsely chopped. A
in bread and egg and mix. The mixture should s
contain pieces. Stir in basil and season with s
and pepper, if necessary.
Stuff the mixture into the calamaretti, close w
toothpicks and place in a baking dish. Seas
with salt and pepper and drizzle with olive
Bake at 390 °F for approx. 10 minutes.

16 Calamaretti, geputzt

2 Karotten, geschält und gewürfelt
2 Zucchini, gewürfelt
8 Garnelen, nur das Schwanzfleisch
3 EL Olivenöl
1 Knoblauchzehe, gehackt
½ Chili, gehackt
Salz, Pfeffer
1 Scheibe Weißbrot, gewürfelt
1 Ei
2 EL Basilikum, gehackt

Karotten und Zucchini in Olivenöl anbraten, das Garnelenfleisch dazugeben und 4 Minuten mitbraten. Den Knoblauch und die Chili zufügen und mit Salz und Pfeffer würzen. Brot und Ei zugeben und im Mixer kurz pürieren. Die Masse sollte noch Stücke enthalten. Basilikum unterheben und evtl. noch mal abschmecken.
Die Masse in die Calamarettimäntel füllen, mit Zahnstochern verschließen und in eine Auflaufform geben. Salzen und pfeffern und mit etwas Olivenöl beträufeln. Bei 200 °C ca. 10 Minuten backen.

6 Calamaretti nettoyés

carottes épluchées en dés
courgettes en dés
crevettes, uniquement la chair des queues
c. à soupe d'huile d'olive
gousse d'ail hachée
2 piment haché
el, poivre
tranche de pain blanc en cubes
œuf
c. à soupe de basilic haché

Faire sauter les carottes et les courgettes dans l'huile d'olive, ajouter la chair des crevettes et poêler 4 minutes. Ajouter l'ail et le piment, saler, poivrer. Incorporer le pain et l'œuf et réduire en purée par un tour de mixeur. L'appareil doit encore comporter des morceaux. Mélanger le basilic et rectifier l'assaisonnement si nécessaire.
Farcir les calamaretti avec cet appareil, fermer avec des cure-dent et déposer dans un moule à gratin. Saler et poivrer ; ajouter quelques gouttes d'huile d'olive. Cuire au four à 200 °C env. 10 minutes.

6 calamares limpios

zanahorias peladas y troceadas
calabacines troceados
gambas (sólo la cola)
cucharadas de aceite de oliva
diente de ajo picado
chile picado
l y pimienta
rebanada de pan blanco troceada en daditos
huevo
cucharadas de albahaca picada

Sofreír las zanahorias y el calabacín en aceite de oliva, añadir las colas de gamba y rehogar la mezcla durante 4 minutos. Agregar el diente de ajo y el chile y salpimentar. Verter el huevo junto con los trozos de pan y pasar brevemente la mezcla por la batidora de forma que contenga tropezones. Añadir la albahaca y sazonar si es necesario.
Rellenar los calamares con la mezcla, cerrarlos con palillos y colocarlos sobre una fuente de horno. Salpimentarlos y rociarlos con aceite de oliva. Rehogarlos durante 10 minutos aprox. a 200 °C.

San Donato in Perano Ristorante

Chef: Augusto Giusti | Owner: Castello di San Donato in Perano S.p.A.

Località San Donato in Perano | 53013 Gaiole in Chianti
Phone: +39 0577 744104
www.sandonatoinperano.it
Opening hours: Every day lunch 12:30 pm to 2:30 pm, dinner 7:30 pm to 9:45 pm
Menu price: € 45
Cuisine: Regional
Special features: Wine shop, outdoor dining

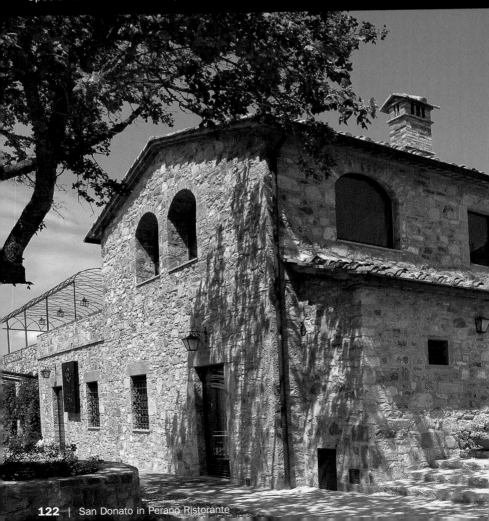

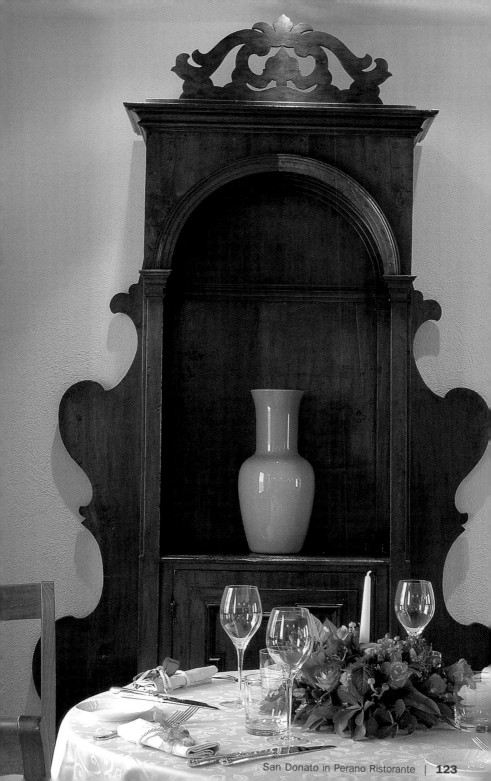

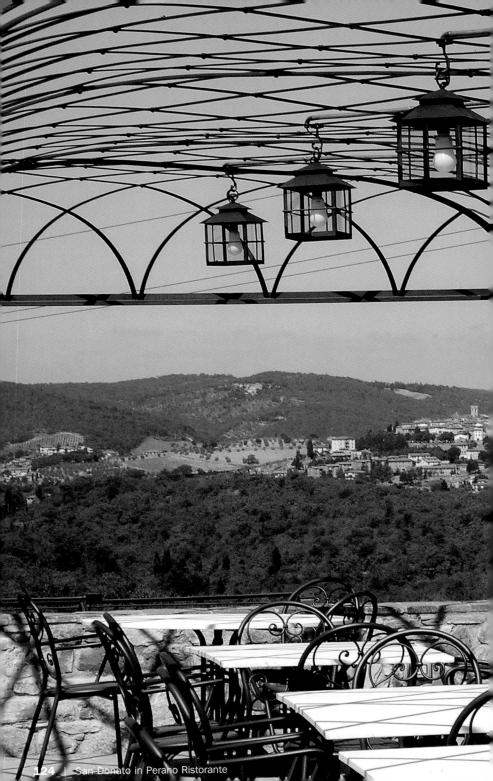

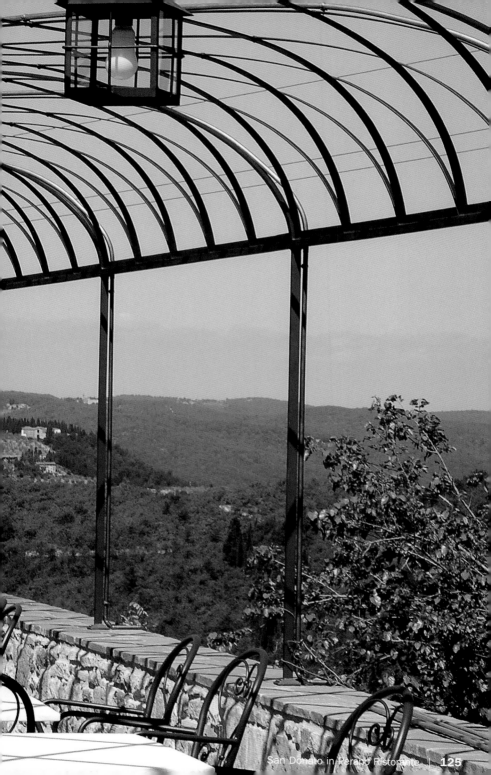

Ravioli stufati

Braised Ravioli

Geschmorte Ravioli

Raviolis braisés

Ravioli rehogados

24 sfoglie di pasta di 5 x 10 cm

1 carota sbucciata e sminuzzata
1 cipolla sminuzzata
4 cucchiai di sedano sminuzzato
3 cucchiai di olio di oliva
1 spicchio d'aglio
50 g di polpa macinata di manzo
50 g di polpa macinata di vitello
50 g di polpa macinata di maiale
2 cucchiai di concentrato di pomodoro
100 ml di vino rosso
1 cucchiaino di timo tritato
1 cucchiaino di origano tritato
50 g di mortadella tagliata a dadini
50 g di prosciutto cotto tagliato a dadini
3 cucchiai di parmigiano grattugiato
1 uovo sodo tagliato a pezzetti
2 cucchiai di prezzemolo tritato

Sale, pepe
1 tuorlo d'uovo sbattuto
Per la guarnizione: lattughina

Soffriggere le verdure nell'olio di oliva, unirvi la carne e l'aglio e rosolare a fuoco vivo. Aggiungere il concentrato di pomodoro e bagnare con il vino rosso. Dare un bollore e condire con sale, pepe, timo e origano. Scolare il liquido di cottura e metterlo da parte. Unire alla carne la mortadella, il prosciutto, il parmigiano, l'uovo e il prezzemolo, assaggiare e, se necessario, regolare il condimento.
Mettere 1 cucchiaio di composto su ogni sfoglia di pasta, spennellare i bordi con il tuorlo d'uovo e chiudere i lembi. Cuocere i ravioli in acqua salata bollente per circa 2 minuti e saltarli nel liquido di cottura tenuto da parte. Guarnire con la lattughina e servire.

Pasta dough sheets, 24 pieces, 2 x 4 inches

1 carrot, peeled and finely diced
1 onion, finely diced
4 tbsp fine celery cubes
3 tbsp olive oil
1 clove of garlic
1 ¾ oz minced beef, minced veal and minced pork each
2 tbsp tomato paste
100 ml red wine
1 tsp thyme, chopped
1 tsp oregano, chopped
1 ¾ oz mortadella, diced
1 3/4 oz ham, diced
3 tbsp Parmesan, grated
1 egg, boiled and diced
2 tbsp parsley, chopped

Salt, pepper
1 egg yolk, whisked
Lambs lettuce for decoration

Sauté the vegetables in olive oil, add the meat and garlic and sear. Add tomato paste and deglaze with red wine. Bring to a boil and season with salt, pepper, thyme and oregano. Drain the liquid and set aside. Fold mortadella, ham, Parmesan, egg and parsley under the meat mixture and season if necessary.
Put 1 tbsp of the mixture on each pasta sheet, brush the edges with egg yolk and fold together. Simmer in salted water for approx. 2 minutes and toss in the reserved braising liquid. Arrange lambs lettuce as decoration.

Nudelteigplatten, 24 Stück á 5 x 10 cm

1 Karotte, geschält und fein gewürfelt
1 Zwiebel, fein gewürfelt
4 EL feine Selleriewürfel
3 EL Olivenöl
1 Knoblauchzehe
je 50 g Rinderhack, Kalbshack und
Schweinehack
2 EL Tomatenmark
100 ml Rotwein
1 TL Thymian, gehackt
1 TL Oregano, gehackt
50 g Mortadella, gewürfelt
50 g gekochter Schinken, gewürfelt
3 EL Parmesan, gerieben
1 Ei, gekocht und gewürfelt
2 EL Petersilie, gehackt

Salz, Pfeffer
1 Eigelb, verquirlt
Feldsalat zur Dekoration

Das Gemüse in Olivenöl anbraten, das Fleisch
und den Knoblauch dazugeben und scharf anbra-
ten. Tomatenmark zugeben und mit Rotwein
ablöschen. Kurz aufkochen und mit Salz, Pfeffer,
Thymian und Oregano würzen. Die Flüssigkeit
abgießen und beiseite stellen. Mortadella,
Schinken, Parmesan, Ei und Petersilie unter die
Fleischmasse heben und evtl. abschmecken.
Jeweils 1 EL der Masse auf die Teigstücke geben,
die Ränder mit Eigelb bestreichen und zuklap-
pen. In siedendem Salzwasser ca. 2 Minuten
gar ziehen lassen und in der zurückbehalte-
nen Bratflüssigkeit schwenken. Mit Feldsalat als
Dekoration anrichten.

Carrés de pâte à nouilles, 24 morceaux de
5 x 10 cm

1 carotte épluchée en petits dés
1 oignon en petits dés
4 c. à soupe de petits dés de céleri
3 c. à soupe d'huile d'olive
1 gousse d'ail
Respectivement 50 g de haché de bœuf, haché
de veau et haché de porc
2 c. à soupe de concentré de tomates
100 ml de vin rouge
1 c. à café de thym haché
1 c. à café d'origan haché
50 g de mortadelle en dés
50 g de jambon blanc en dés
3 c. à soupe de parmesan râpé
1 œuf cuit dur et coupé en dés
2 c. à soupe de persil ciselé

Sel, poivre
1 jaune d'œuf battu
Mâche pour la décoration

Faire revenir les légumes dans l'huile d'olive,
ajouter la viande et l'ail et saisir à vif. Ajouter
le concentré de tomates et mouiller avec le vin
rouge. Faire bouillir un instant et assaisonner de
sel, poivre, thym et origan. Verser le jus dans une
jatte et réserver. Incorporer la mortadelle, le jam-
bon, le parmesan, l'œuf et le persil à la viande et
rectifier l'assaisonnement.
Déposer 1 c. à soupe de farce sur les carrés de
pâte, badigeonner les bords de jaune d'œuf et
fermer. Faire cuire dans de l'eau salée frémis-
sante env. 2 minutes et poêler dans le jus de
cuisson réservé à part. Servir avec de la mâche
en décoration.

24 planchas de pasta de 5 x 10 cm

1 zanahoria pelada y muy picada
1 cebolla muy picada
4 cucharadas de apio picado
3 cucharadas de aceite de oliva
1 diente de ajo
50 g de carne picada de añojo, ternera y cerdo
respectivamente
2 cucharadas de tomate concentrado
100 ml de vino tinto
1 cucharadita de tomillo picado
1 cucharadita de orégano picado
50 g de mortadela en daditos
50 g de jamón cocido en daditos
3 cucharadas de parmesano rallado
1 huevo cocido y picado
2 cucharadas de perejil picado

Sal y pimienta
1 yema de huevo batida
Canónigos para decorar

Sofreír la verdura en aceite de oliva, añadirle la
carne y el ajo y dorarlos. Incorporar el tomate
concentrado y rociarlo con vino tinto. Rehogar
brevemente y sazonar con pimienta, sal y tomi-
llo. Quitar el jugo resultante y reservarlo aparte.
Añadir a la masa de carne la mortadela, el
jamón, el parmesano, el huevo y sazonarla si es
necesario.
Colocar 1 cucharada de la mezcla por cada trozo
de pasta, untar los bordes con yema de huevo
y cerrar los trozos de pasta. Cocerlos en agua
salada en ebullición durante 2 minutos aprox. y
a continuación saltearlos en el jugo de la carne.
Decorar con los canónigos.

Teatro del Sale

Chef, Owner: Fabio Picchi

Via dei Macci 111/R | 50122 Florence
Phone: +39 055 2001492
www.teatrodelsale.com
Opening hours: Tue–Sat 9 pm to midnight
Average price: € 20
Cuisine: Tuscan, traditional
Special features: Cultural events and access for members

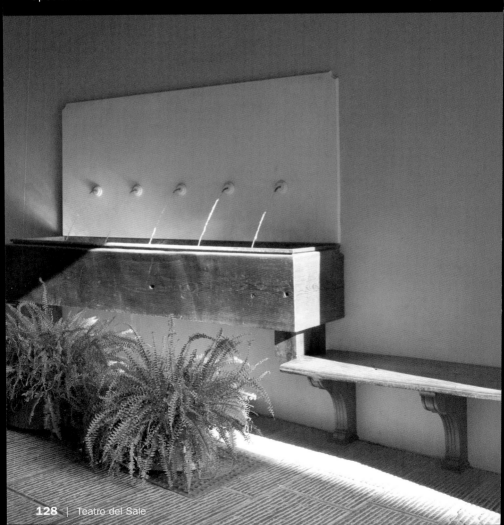

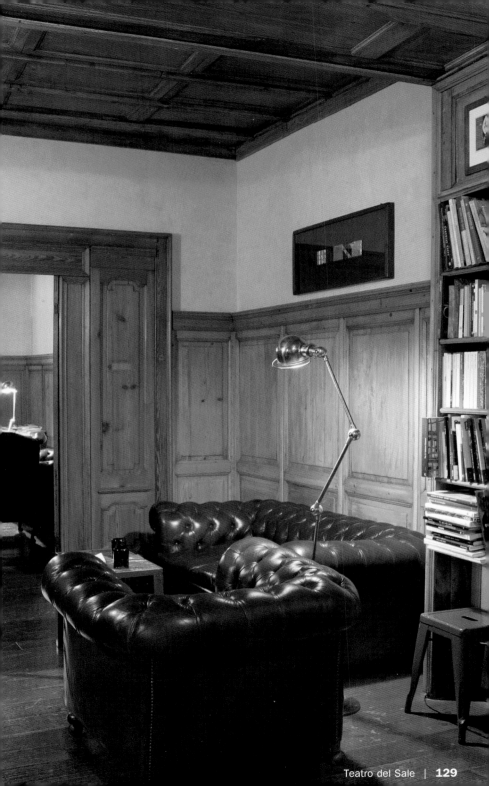

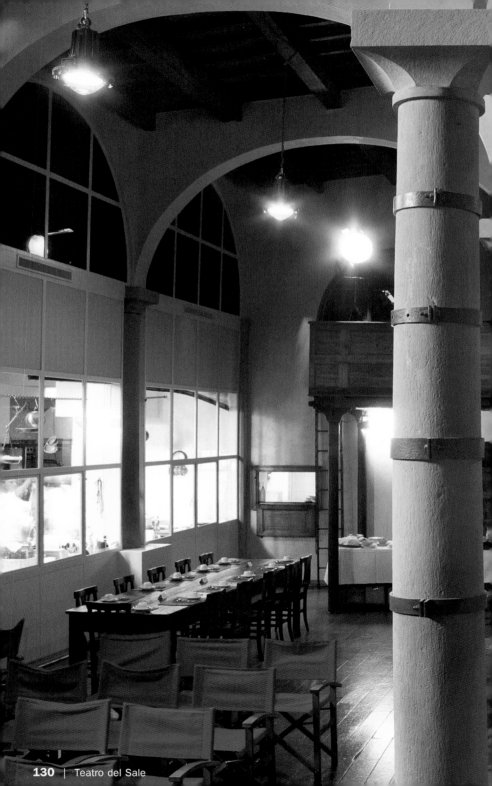

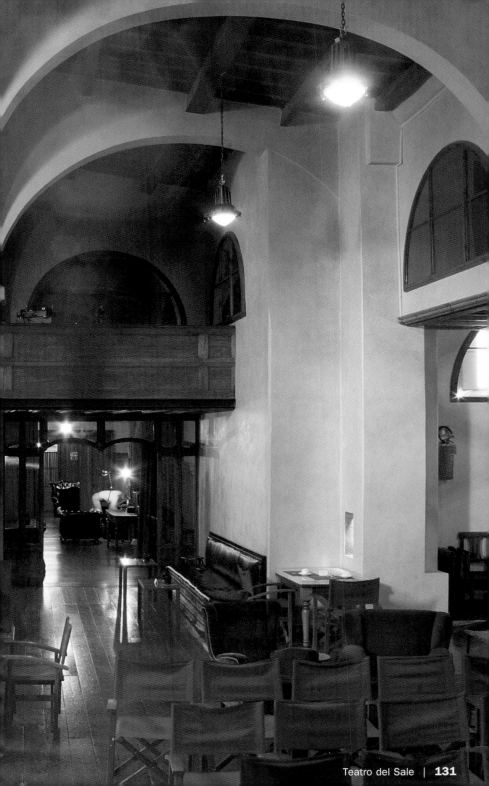

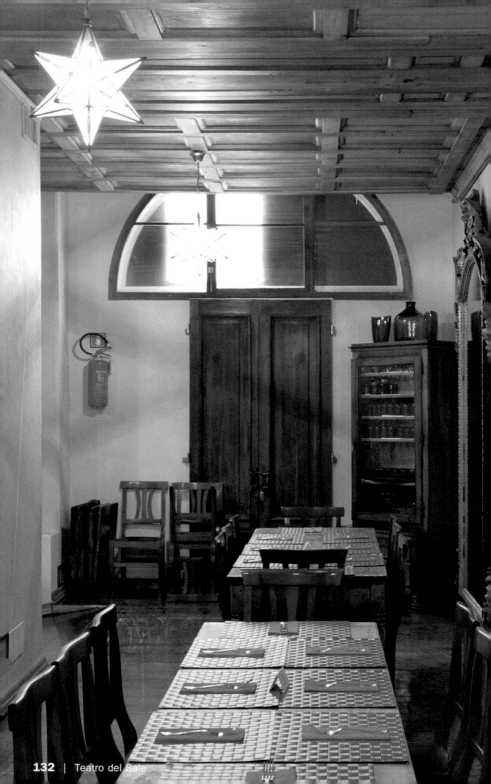

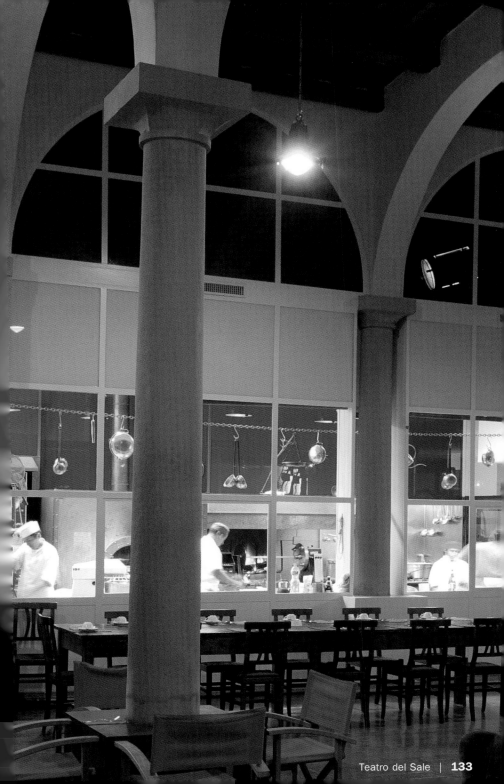

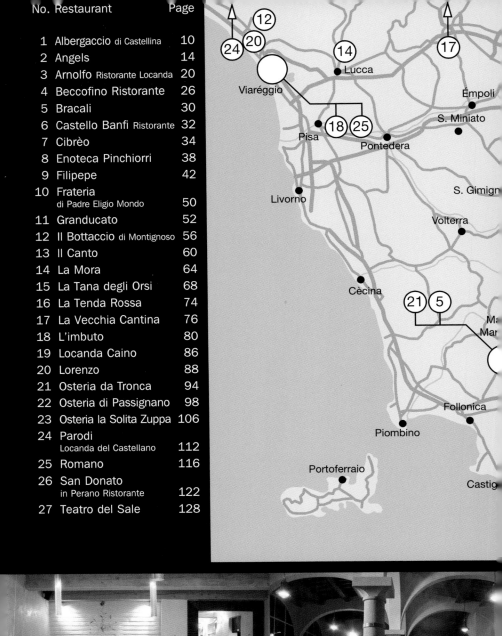

Lucca
Viaréggio
Émpoli
S. Miniato
Pisa
Pontedera
Livorno
S. Gimign
Volterra
Cècina
M;
Mar
Follonica
Piombino
Portoferraio
Castig

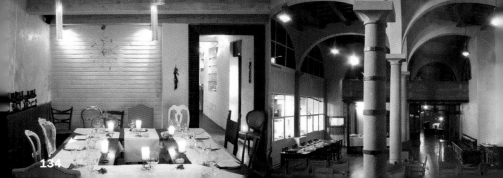

134

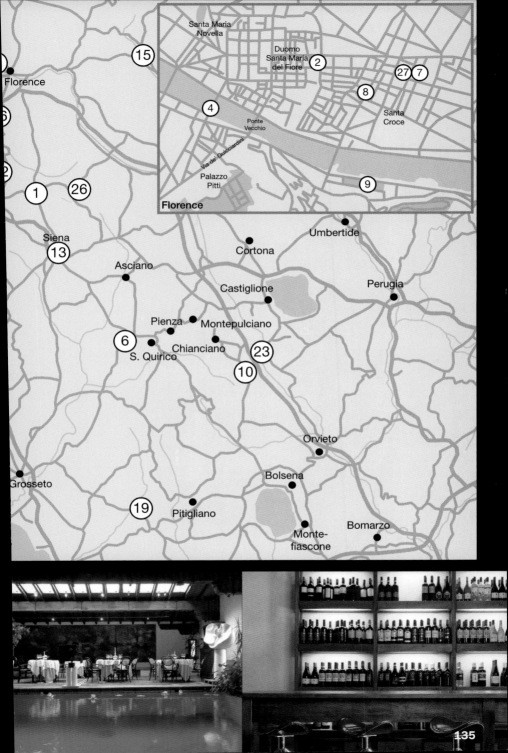

Cool Restaurants

Size: 14 x 21.5 cm / 5 $\frac{1}{2}$ x 8 $\frac{1}{2}$ in.
136 pp, Flexicover
c. 130 color photographs
Text in English, German, French, Spanish, Italian or (*) Dutch

Other titles in the same series:

Amsterdam
ISBN 3-8238-4588-8

Barcelona
ISBN 3-8238-4586-1

Berlin
ISBN 3-8238-4585-3

Brussels (*)
ISBN 3-8327-9065-9

Cape Town
ISBN 3-8327-9103-5

Chicago
ISBN 3-8327-9018-7

Cologne
ISBN 3-8327-9117-5

Côte d'Azur
ISBN 3-8327-9040-3

Frankfurt
ISBN 3-8237-9118-3

Hamburg
ISBN 3-8238-4599-3

Hong Kong
ISBN 3-8327-9111-6

Istanbul
ISBN 3-8327-9115-9

Las Vegas
ISBN 3-8327-9116-7

London 2nd edition
ISBN 3-8327-9131-0

Los Angeles
ISBN 3-8238-4589-6

Madrid
ISBN 3-8327-9029-2

Mallorca/Ibiza
ISBN 3-8327-9113-2

Miami
ISBN 3-8327-9066-7

Milan
ISBN 3-8238-4587-X

Munich
ISBN 3-8327-9019-5

New York 2nd edition
ISBN 3-8327-9130-2

Paris 2nd edition
ISBN 3-8327-9129-9

Prague
ISBN 3-8327-9068-3

Rome
ISBN 3-8327-9028-4

San Francisco
ISBN 3-8327-9067-5

Shanghai
ISBN 3-8327-9050-0

Sydney
ISBN 3-8327-9027-6

Tokyo
ISBN 3-8238-4590-X

Vienna
ISBN 3-8327-9020-9

Zurich
ISBN 3-8327-9069-1

To be published in the same series:

Dubai	Moscow
Copenhagen	Singapore
Geneva	Stockholm

teNeues